POSTCARD HISTORY SERIES

Chester

On the front cover: This is a restored view of the 1724 courthouse located in Chester. The courthouse contains its original bell that was rung when the Declaration of Independence was read in 1776. The bell is one of the original "liberty bells" in the American colonies. (David Guleke.)

On the back cover: Roders newsstand is located at Seventh and Welsh Streets and Edgmont Avenue. It was originally built as a cigar stand in 1880, called the Lighthouse. After a fire in 1912, it was rebuilt. Still in operation, it was renovated in 2001. The "smallest block in America" is its nickname. (David Guleke.)

POSTCARD HISTORY SERIES

Chester

Chester Historical Preservation Committee

ARCADIA
PUBLISHING

Copyright © 2008 by Chester Historical Preservation Committee
ISBN 978-0-7385-6348-0

Published by Arcadia Publishing
Charleston SC, Chicago IL, Portsmouth NH, San Francisco CA

Printed in the United States of America

Library of Congress Catalog Card Number: 2008928783

For all general information contact Arcadia Publishing at:
Telephone 843-853-2070
Fax 843-853-0044
E-mail sales@arcadiapublishing.com
For customer service and orders:
Toll-Free 1-888-313-2665

Visit us on the Internet at www.arcadiapublishing.com

CONTENTS

ACKNOWLEDGMENTS

A special acknowledgment is extended to David Guleke for the use of his extensive postcard collection of Chester. He has dedicated himself to Chester Historical Preservation Committee since its incorporation in 1983.

We also extend our gratitude to the Delaware County Historical Society for the use of its postcard collection. Margaret Johnson, library coordinator, assisted with scanning the postcards for this book at the historical society.

Robert Quay, a member of Chester Historical Preservation Committee, assisted with the scanning and editing of this book.

Bob O'Neill graciously wrote the introduction to the book. He was a reporter in Chester for a number of years.

Many thanks go to the Chester Historical Preservation Committee members who have spent endless hours in the preparation of this book. Members include David Guleke (president), Carol Fireng (vice president), Doris Vermeychuk (secretary), Helen Litwa, Dan Vermeychuk, Robert Quay, and Ed Broadfield.

Unless otherwise noted, all images in this book are from the collection of David Guleke. Other postcards reproduced here are from either the collection of the Delaware County Historical Society or from the Chester Rural Cemetery Association.

INTRODUCTION

Postcard publishing dates from before the dawn of the 20th century when America was a kinder, gentler nation of small towns insulated from one another by distance, poor roads, lack of automobiles, and strong community pride. It was this sense of belonging that prompted businesses in Chester and other towns across the country as far back as 1907 to photograph and print postcards for sale to their customers. The cards originally sold for a penny, the same price as the required postage.

The more familiar and attractive the photograph scene, the better the sale, and the early days of Pennsylvania's oldest city offered both. Many pictures of Chester Creek, Pennsylvania Military College's Old Main, waterfront industries, Market Street businesses, parks, schools, and neighborhoods were sent to Germany in earlier days for colorization, although the prints included in this publication have been changed to black and white.

Like today's e-mail, postcards were initially attractive as a quick and easy medium to send messages, with the added bonus of a picture of the sender's—or perhaps receiver's—hometown. As far back as 1873, when the first postal card was issued, there were no pictures. That came about with the Ulysses S. Grant card in 1891, but senders could not write on the back. Their message had to be scrolled on the picture side. The divided back for message and address was initiated in 1907, and interest in the cards took off.

Almost all the postcards included in this publication are dated from 1907 to the 1950s. Postcards today are purchased mostly by tourists and travelers, and they are usually collected as reminders of where they have been. Chester postcards have been collectibles among local residents for many years, a source of community pride that has now become nostalgia. The world, not just Chester, has changed over the past 80 years. The cards depicted here reflect that change. Buildings have been altered or demolished. Businesses have disappeared. Familiar scenes have faded and changed with the passing years. Even Market Street, one of the oldest thoroughfares in the nation, is closed off and renamed.

If you loved the city and the streets you played on as a child, the world you took for granted, the movie theaters you attended that are gone forever, and you strain to recall scenes that recede further from the reaches of your memory with each passing year, then let these postcards vicariously return you, for a moment, to Chester.

—Bob O'Neill, Delaware County Historical Society

One

EDUCATION AND
THE ARTS

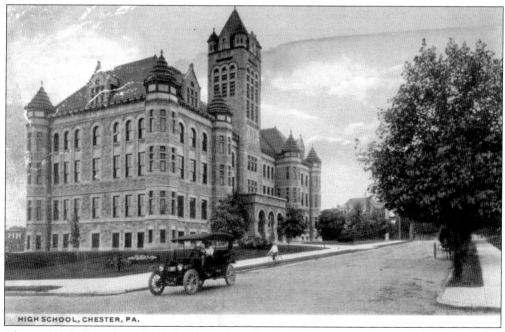

HIGH SCHOOL, CHESTER, PA.

Chester High School was built in 1901 of granite by William Provost Jr. at the cost of nearly $168,000. The high school consisted of 44 rooms and castlelike towers, and it was located at Ninth and Fulton Streets. Most everyone in Chester attended Chester High School. The first class of the new school graduated in 1905, with T. S. Cole serving as the first principal.

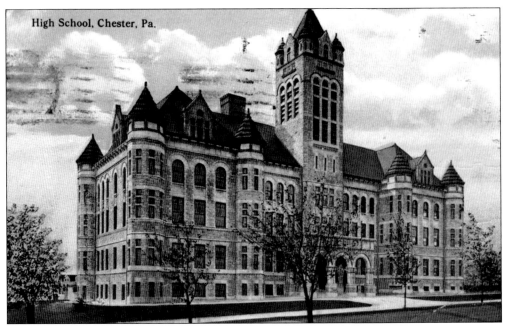

High School, Chester, Pa.

This building had graduates until 1968, when it was gutted and then razed due to fire. Throughout its existence, Chester High School was one of the landmarks of the city of Chester, and views of it were top-selling postcards for visitors to the city. Everyone will always remember Chester High School in the ring's black onyx stone.

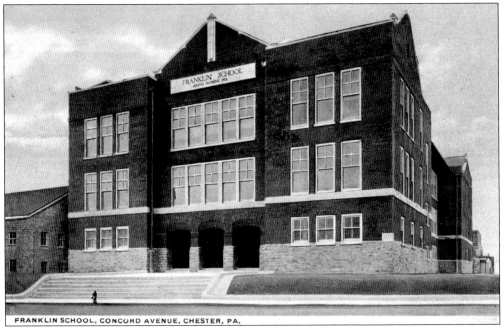

FRANKLIN SCHOOL, CONCORD AVENUE, CHESTER, PA.

Built in 1910, the Franklin School was located on Concord Avenue between Third and Fourth Streets. Famed Pittsburgh Pirates coach Danny Murtaugh was a student at Franklin School. The school's condition was a focal point in the fight for better school conditions for African American children in the 1960s.

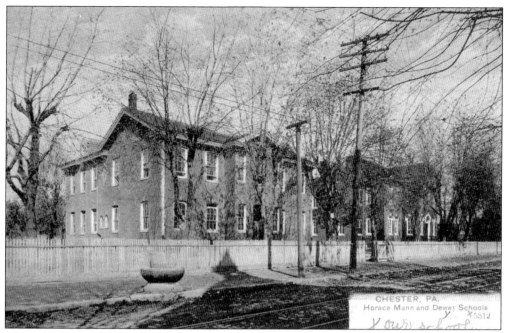

The Horace Mann School was named after Horace Mann, a great American educational reformer. Built around 1914, it housed grades one through six and was located on Third Street between Jeffrey and Yarnell Streets.

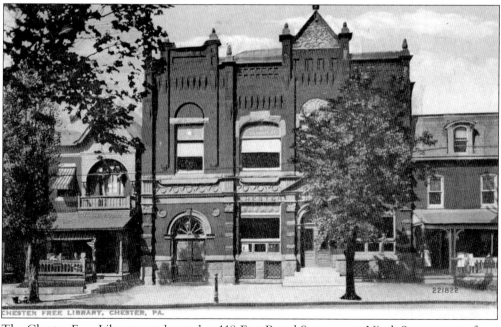

The Chester Free Library was located at 118 East Broad Street, now Ninth Street, across from Larkin School. There were approximately 35,000 volumes in the library. The building was demolished in April 1963.

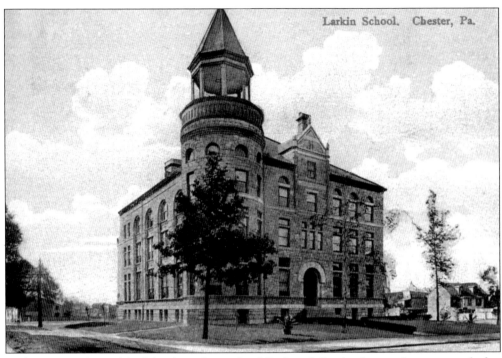

Built in 1894, the Larkin School was located at Ninth and Crosby Streets. It was named after John Larkin Jr., a prominent resident of the area and the first mayor of the city of Chester. In June 1975, it was closed. On September 1, 1977, it was destroyed by fire, and the remainder was demolished in 1978.

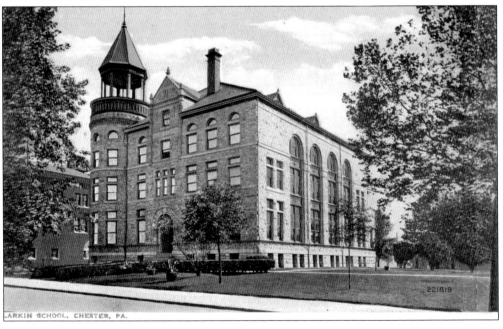

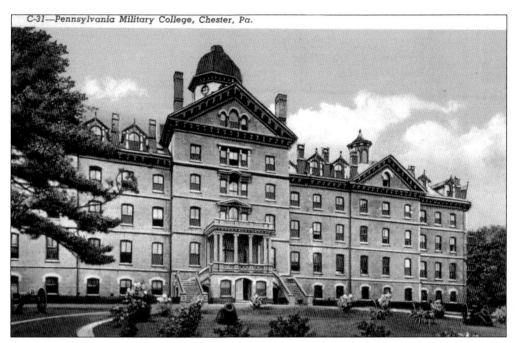

Old Main was one of the original buildings of the Pennsylvania Military College when the school relocated to Chester in 1866. Originally built in 1867 of stone and stucco, Old Main was renovated in 1883 after a fire practically destroyed the upper floor.

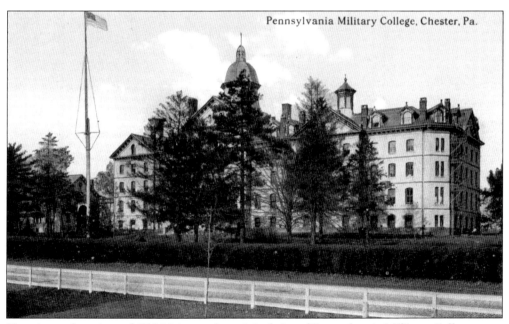

Pennsylvania Military College, Chester, Pa.

Here is another view of Old Main on the original site of Pennsylvania Military College, now Widener University. Today Seventeenth Street has replaced the lane behind the fence seen on the postcard. (Delaware County Historical Society.)

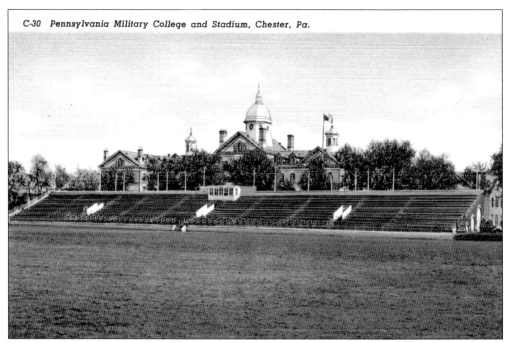

C-30 *Pennsylvania Military College and Stadium, Chester, Pa.*

The Pennsylvania Military College stadium, now the stadium for Widener University, is the place where all the college's home games were played.

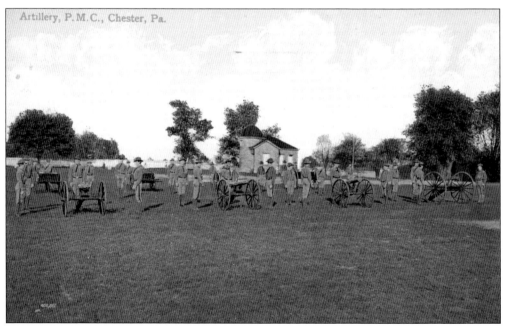

Artillery, P.M.C., Chester, Pa.

This postcard shows the Pennsylvania Military College cadets being instructed in the use of an early-20th-century canon.

Here the cadets are doing their military drill on horseback.

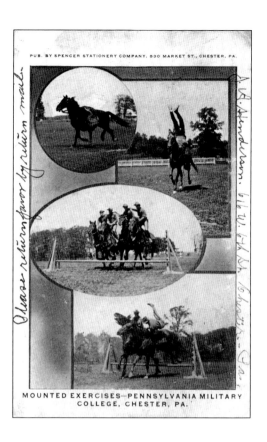

MOUNTED EXERCISES—PENNSYLVANIA MILITARY
COLLEGE, CHESTER, PA.

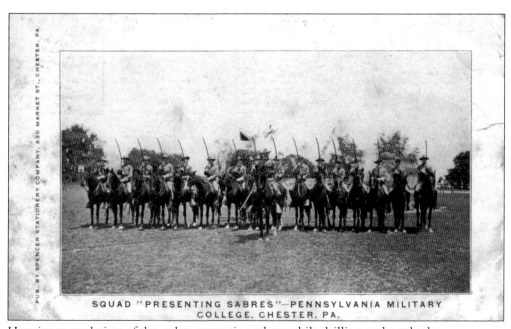

SQUAD "PRESENTING SABRES"—PENNSYLVANIA MILITARY
COLLEGE, CHESTER, PA.

Here is a second view of the cadets presenting sabers while drilling on horseback.

The cadets behind the flag are passing in review before their officers. This meant that while the company assembled at the left in the background, the cadets had to turn to march around in order to be inspected.

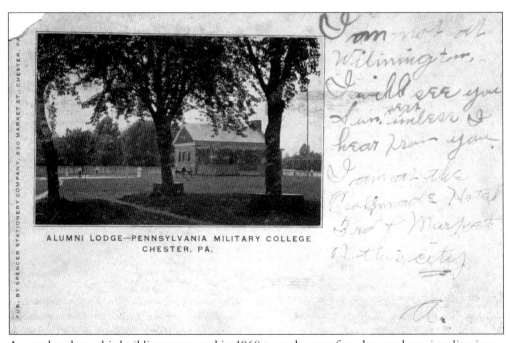

ALUMNI LODGE—PENNSYLVANIA MILITARY COLLEGE
CHESTER, PA.

A popular place, this building was razed in 1960 to make way for a larger alumni auditorium.

Kirkbridge Hall is located at Seventeenth and Walnut Streets. Built in 1965, it houses the school of engineering and the science division of the College of the Arts and Sciences for Widener University.

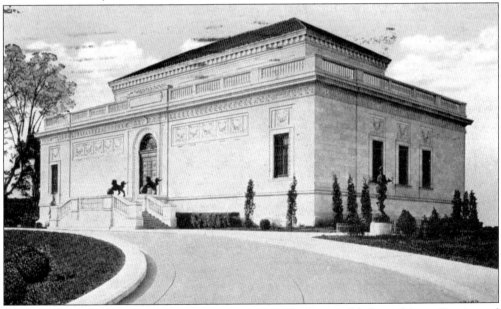

The Alfred O. Deshong Museum was built in 1914 of white marble by architects Brazier and Robb. The museum is located on the north end of the Deshong estate. Deshong's will stipulated that the art collection be left to the people of Chester. Along with the collection, $500,000 was left to build and maintain a fireproof art gallery. The museum displayed priceless works of art in oil, ivories, bronzes, and oriental carpets. Deshong collected these great works of art during his many tours around the world. The Deshong museum was the first public art gallery in the eastern United States.

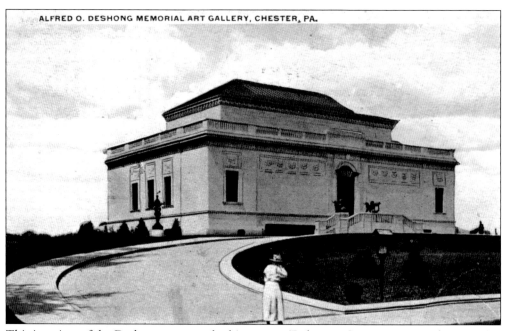

This is a view of the Deshong museum looking west. (Delaware County Historical Society.)

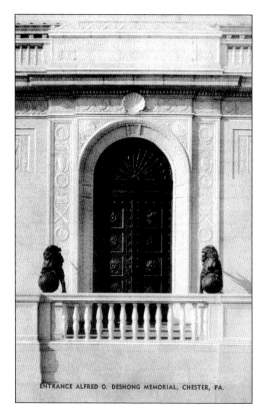

The Deshong museum entrance is made of marble and was executed by Donnelly and Ricci. The bronze doors were treated to give them a patina similar to the ancient bronze treasures placed around the museum.

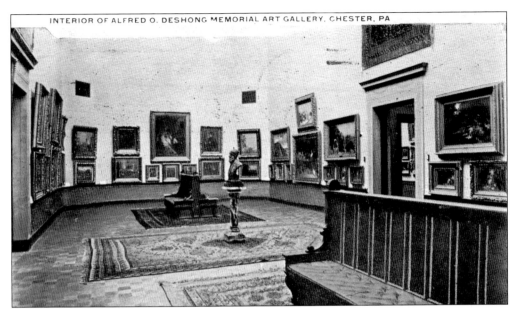

The main gallery of the Deshong museum was modeled after the dimensions of the German emperor's gallery at Cassel. The galleries were fireproof. Paintings and rare rugs were hung in the main gallery.

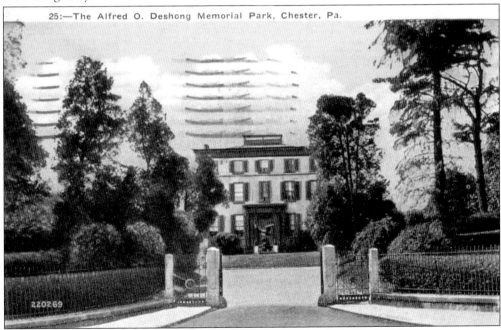

25:—The Alfred O. Deshong Memorial Park, Chester, Pa.

The Deshong mansion was built in 1850 in the Greek Revival Italianate style by John O. Deshong Sr. It is located at Ninth Street and Edgmont Avenue. The mansion and its 22 acres became the Deshong family estate. It is best known for its famed art collection by his son Alfred O. Deshong. The property was donated to the City of Chester for the benefit of its citizens in 1913. This large three-story mansion played host to the powerful and influential men of the era. The estate consisted of the mansion, the large carriage house, and the collection of rare specimen trees. Currently this is considered an endangered historic site.

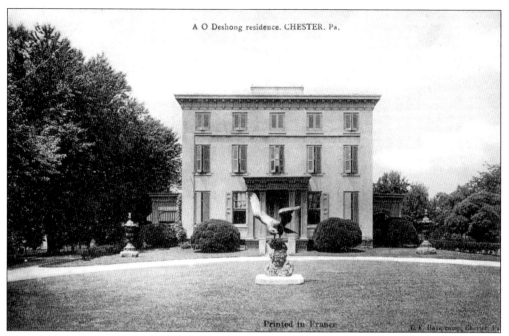

This bronze eagle was located directly in front of the entrance to the Deshong mansion.

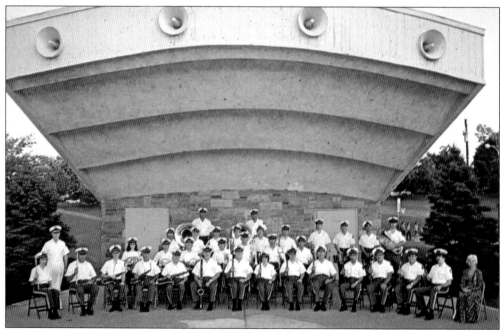

The Chester Park band shell was built in the 1950s. The names of the band members pictured here are unknown. The Chester City Band still gives concerts in the shell.

Two

CHURCHES, CEMETERIES, AND MEMORIALS

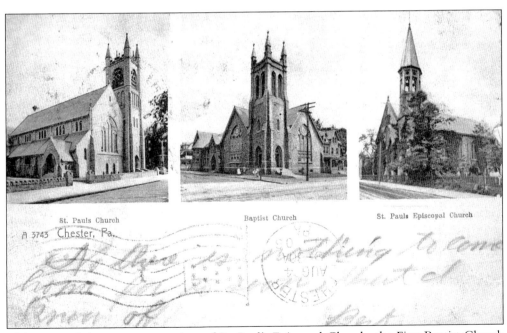

This postcard shows a current view of St. Paul's Episcopal Church, the First Baptist Church (middle), and the original, old St. Paul's Episcopal Church.

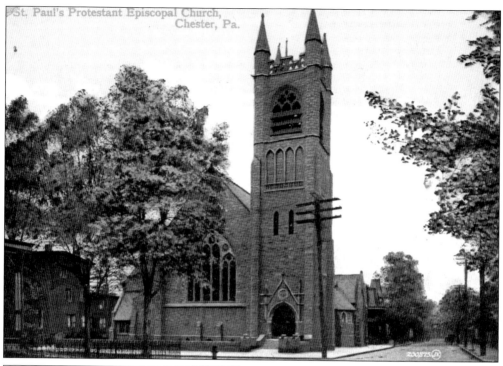

St. Paul's Protestant Episcopal Church, Chester, Pa.

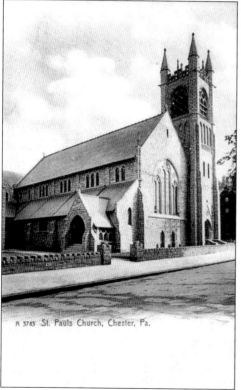

A 3743 St. Pauls Church, Chester, Pa.

These two views are of St. Paul's Episcopal Church. This, the present granite building, was completed in 1900 and still stands at the corner of Ninth and Madison Streets. It was designed by William Provost Jr.

There is some difference as to exact dates, but the church located on the northwest corner of Third and Welsh Streets, referred to as old St. Paul's Church, was built in 1850. It is the second St. Paul's Church to be built. The building was enlarged in 1878 when the steeple and bell tower were added. The building was razed in 1952 to make a parking lot.

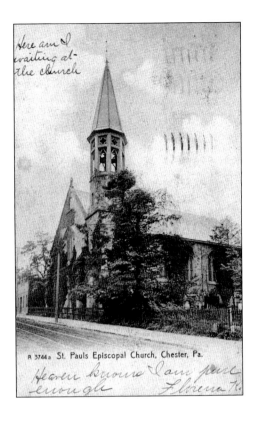

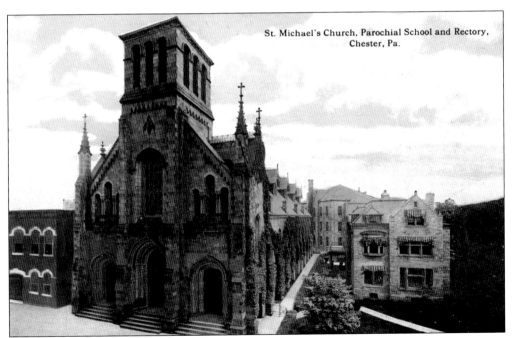

St. Michael's Church and Rectory is located on Edgmont Avenue. The church's cornerstone was laid on November 1, 1874, and the building was dedicated on November 5, 1882.

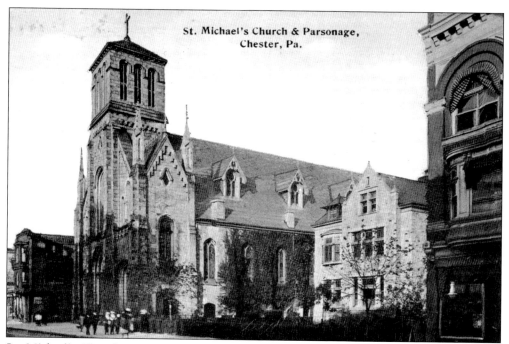

St. Michael's Church was a popular building and is seen on postcards in many views of Edgmont Avenue.

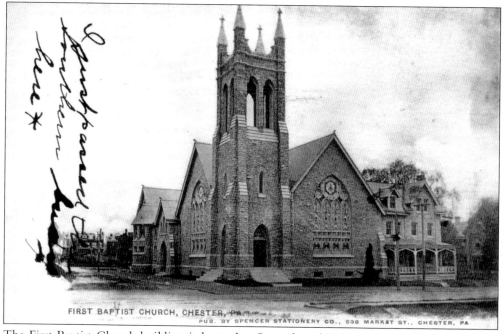

The First Baptist Church building is located at Seventh and Fulton Streets. The cornerstone was laid on August 11, 1894. In 1976, the building was sold to Range's Temple Church of God in Christ.

The cornerstone of the Immaculate Heart Catholic Church, located at the northwest corner of Second and Norris Streets, was laid on September 23, 1874. The church was dedicated in October 1876.

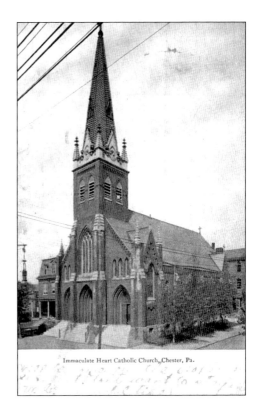

Immaculate Heart Catholic Church, Chester, Pa.

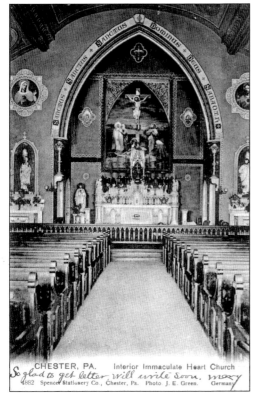

CHESTER, PA. Interior Immaculate Heart Church
1882 Spencer Stationery Co., Chester, Pa. Photo J. E. Green. Germany

The interior of Immaculate Heart Catholic Church, as seen in this postcard view, shows the magnificent marble altar and statues. Today the church is used for special events and funerals. The basement of the church houses St. Katharine Drexel's food cupboard.

25

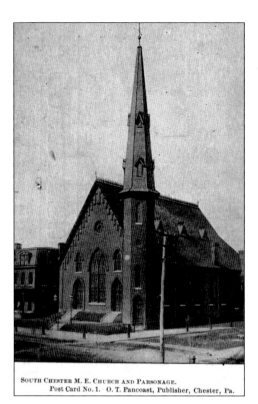

The South Chester Methodist Episcopal Church is located at the corner of Third and Jeffrey Streets.

SOUTH CHESTER M. E. CHURCH AND PARSONAGE.
Post Card No. 1. O. T. Pancoast, Publisher, Chester, Pa.

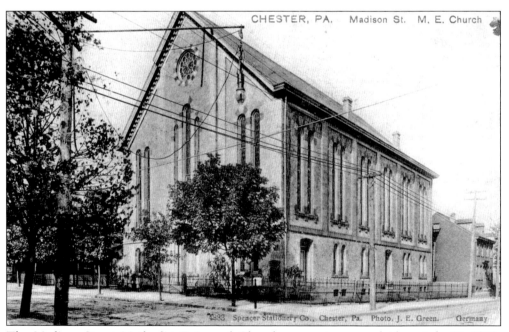

CHESTER, PA. Madison St. M. E. Church

The Madison Street Methodist Episcopal Church cornerstone was laid on July 17, 1872. The church is located at Seventh and Madison Streets, two blocks west of St. Paul's Episcopal Church.

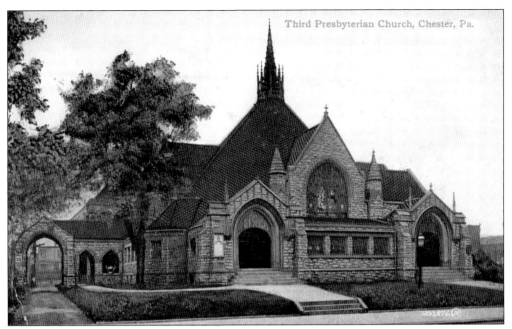

The Third Presbyterian Church, located at 34 East Ninth Street, was completed in May 1896. This was the site of the world's first summer Bible school in 1912.

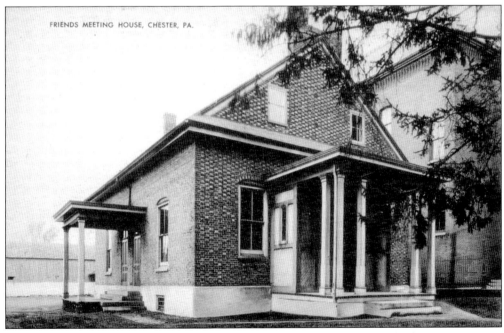

This is a view of the Chester Meeting House of the Society of Friends built in 1736. It was located on Market Street below Third Street. The building was demolished in the 1950s.

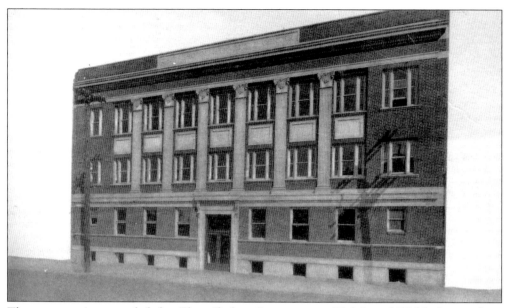

The congregation attended the Ohev Sholom Synagogue at Eighth and Welsh Streets from 1927 to 1965. The congregation relocated to the new synagogue at the intersection of Route 320 and Route 252 in Wallingford. (Delaware County Historical Society.)

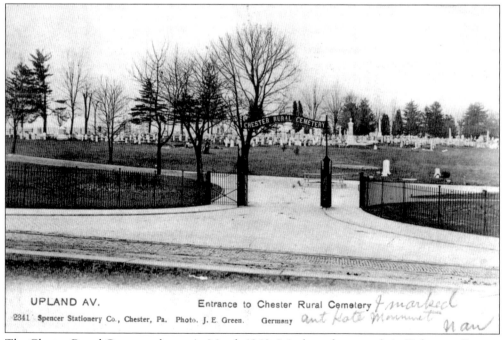

UPLAND AV. Entrance to Chester Rural Cemetery

2341 Spencer Stationery Co., Chester, Pa. Photo. J. E. Green. Germany

The Chester Rural Cemetery began in March 1863. It is the only example in Delaware County of a rural cemetery in the days before public parks. The first known interments were of Civil War casualties both Union and Confederate.

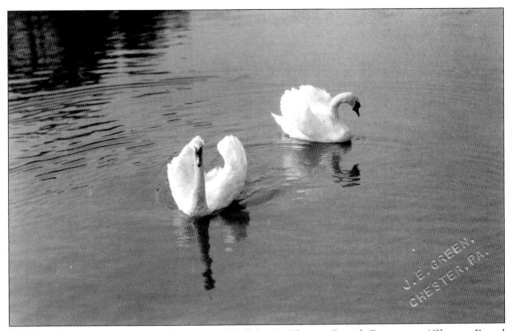

These beautiful swans were a fixture in the lake in Chester Rural Cemetery. (Chester Rural Cemetery Association.)

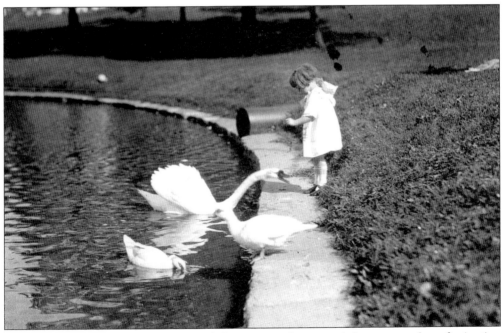

The swans in the lake at Chester Rural Cemetery swim around the water and are fascinating an unidentified little girl. (Chester Rural Cemetery Association.)

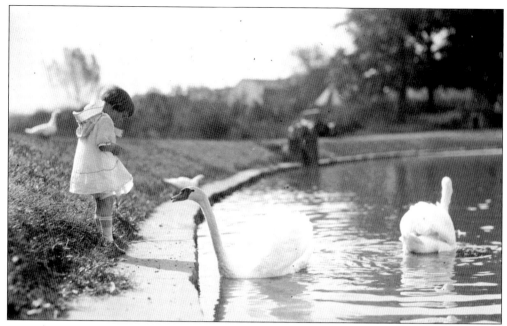

Now the swans are intrigued, and they move in closer as the girl offers some food. (Chester Rural Cemetery Association.)

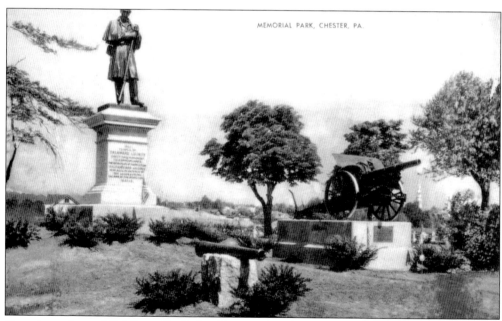

Here is a view of Soldiers Circle in Chester Rural Cemetery. Veterans from the Civil War through present-day conflicts are buried in this area. There are also monuments to commemorate each war since the Civil War.

Here is another view of Soldiers Circle in Chester Rural Cemetery. The inscription on the monument reads, "The people of Delaware County erected this monument to commemorate the patriotism of their citizens, soldiers and sailors who fell in defense of the Union in the War of the Rebellion 1861-65."

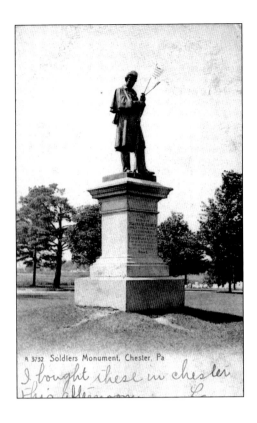

A 3732 Soldiers Monument, Chester, Pa

I bought these in chester

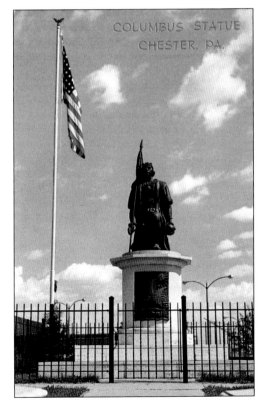

COLUMBUS STATUE
CHESTER, PA.

The Columbus monument is located next to the old Swedish burial ground. It was erected by various organizations of Italian heritage in Chester in 1955, and it commemorates Columbus's discovery of the New World. The artist who executed the statue was Antonio Venditti. (Delaware County Historical Society.)

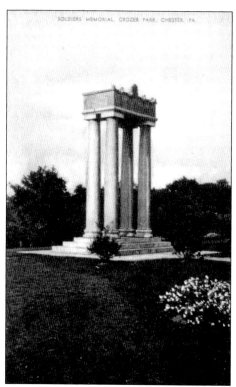

This soldiers' monument was constructed using the pillars from the Chester National Bank.

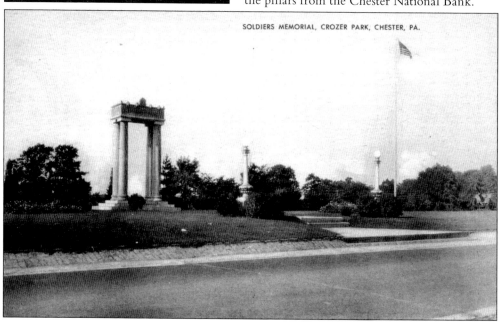

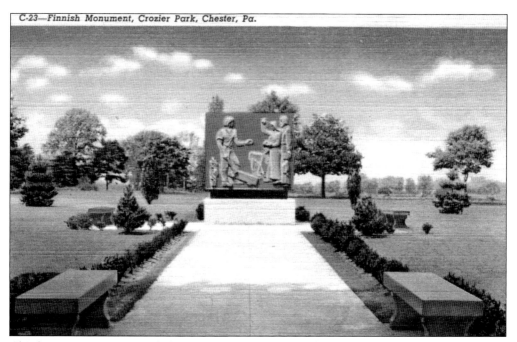

C-23—Finnish Monument, Crozier Park, Chester, Pa.

This large monument was dedicated on June 29, 1938. The Finnish monument was placed in Crozer Park to commemorate the 300th anniversary of the first Finnish settlement in America. (Delaware County Historical Society.)

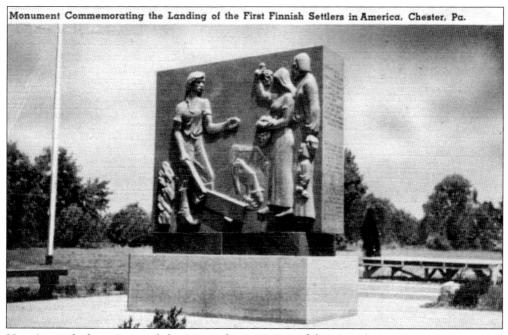

Here is a real-photo postcard showing a close-up view of the Finnish monument.

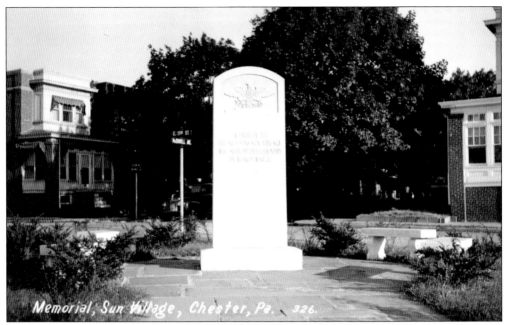

This is a monument dedicated to those citizens of Sun Village who gave up their lives in World War II. (Delaware County Historical Society.)

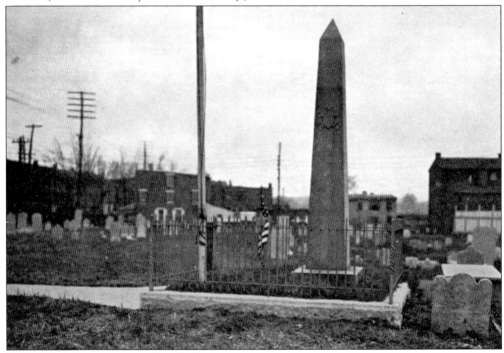

St. Paul's burying ground, also called the old Swedish burial ground, is located on the site of the first St. Paul's Episcopal Church, which was built in 1702. Many prominent leaders of the area are buried in this cemetery. David Lloyd, the first chief justice of Colonial Pennsylvania, and John Morton, signer of the Declaration of Independence, both rest here. (Delaware County Historical Society.)

Three

STORES AND BUSINESSES

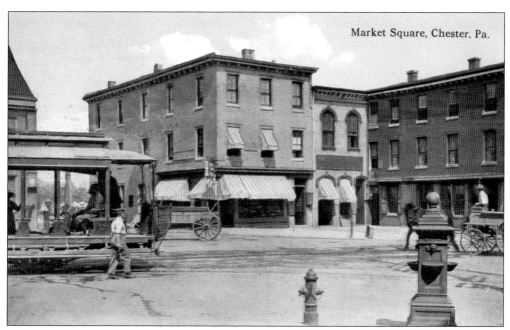

This scene shows Broomall's Department Store (with the awnings), which later became Stotter's. There is also a horse-drawn trolley that is turning around. This Market Square was originally laid out by William Penn as one of only four in Pennsylvania. The square was eventually developed and is now the site of the city administration building.

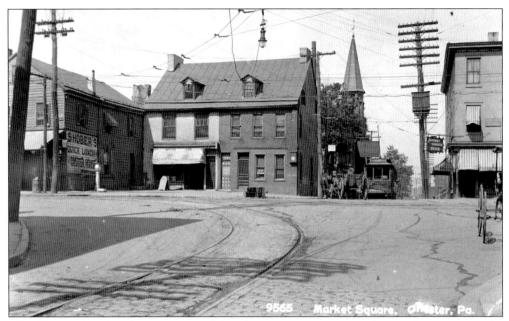

The Chester Traction Company served the city over many years, and it was by no means the only company to do so. The trolley in this postcard is a Philadelphia Rapid Transit car and has a destination sign that reads, "Short Line via Subway, Chester and Philadelphia."

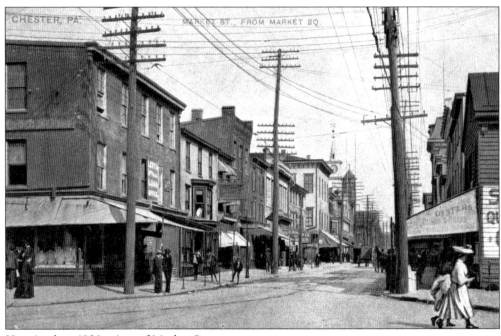

Here is a late-1920s view of Market Square.

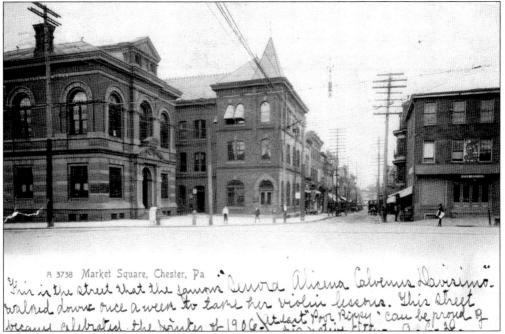

This is a view of Market Square and the Wolf building. The Wolf building, which housed the Bank of Delaware County, is the substantial-looking structure on the left. Constructed in 1882, it was the second building of the Bank of Delaware County. It replaced an earlier bank building that was constructed in 1815.

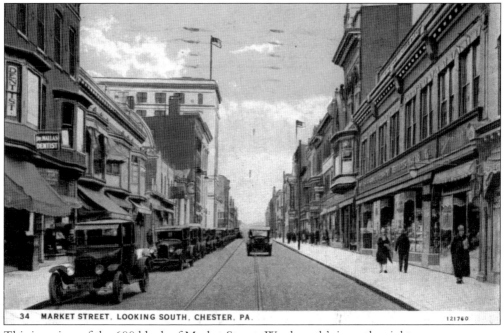

34 MARKET STREET, LOOKING SOUTH, CHESTER, PA. 121760

This is a view of the 600 block of Market Street. Woolworth's is on the right.

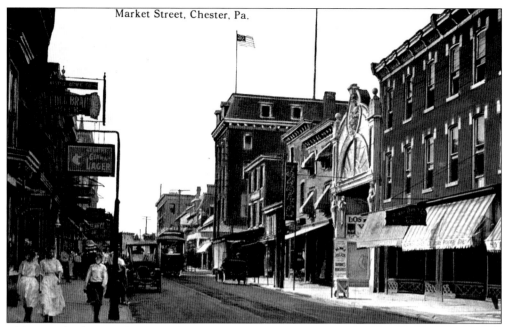

Market Street, Chester, Pa.

This view looks east along Market Street. Note the sign on the left advertising the Chester Brewing Company and some of its varieties.

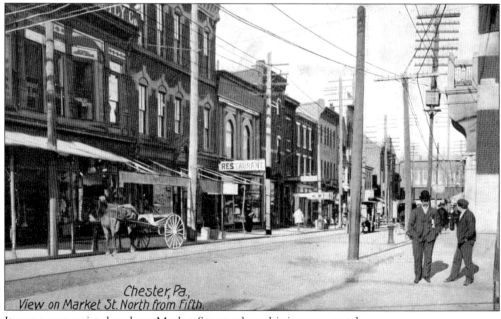

Chester, Pa.,
View on Market St. North from Fifth.

It was a very quiet day along Market Street when this image was taken.

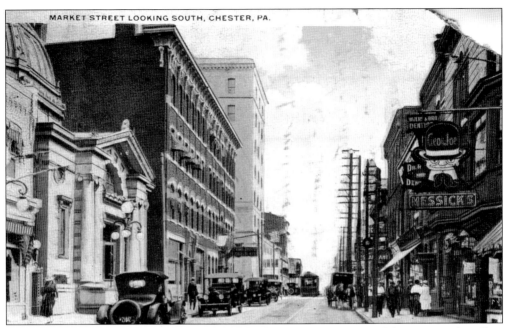

The Chester National Bank building is the domed building on the left of this image. The pillars of the bank were reused in the soldiers' monument in Crozer Park. The white sandstone of the Crozer building can be seen rising farther down the block.

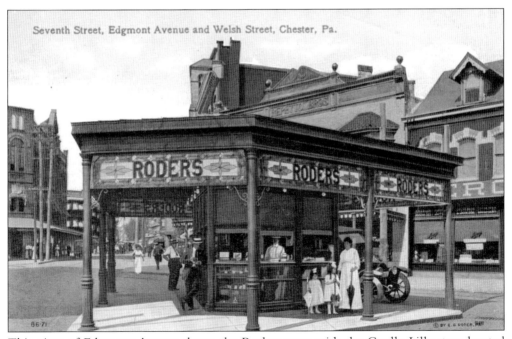

This view of Edgmont Avenue shows the Roders store with the Coolly Lilly store located behind it. Coolly Lilly's address was 203 Edgmont Avenue, and it opened on August 7, 1919. It sold dishes and stemware and had a bridal registry. A toy store was located in the basement.

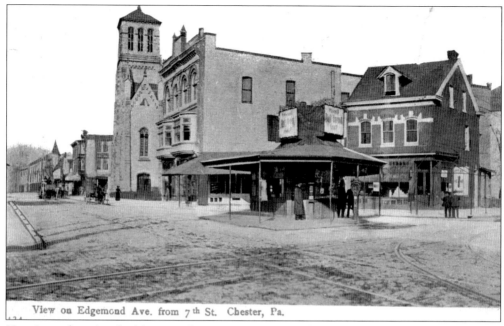

View on Edgemond Ave. from 7th St. Chester, Pa.

Here is another view looking up Edgmont Avenue toward Ninth Street showing Roders store with the Coolly Lilly store behind it.

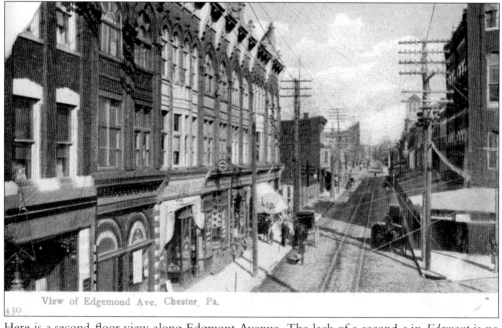

View of Edgemond Ave. Chester, Pa.

Here is a second-floor view along Edgmont Avenue. The lack of a second *e* in *Edgmont* is no error, although nothing now records the reason for this unusual name.

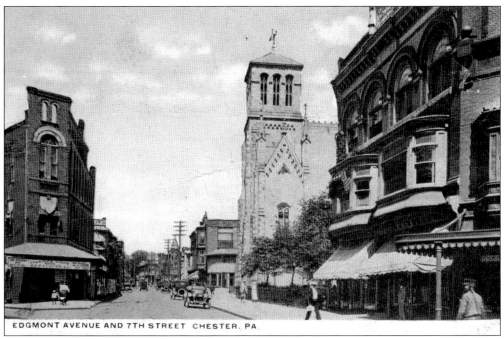

EDGMONT AVENUE AND 7TH STREET CHESTER. PA.

The redbrick building seen on the left of this photograph houses the Chester White Shoe Repairing Company. The grey stone spire belongs to St. Michael's Church.

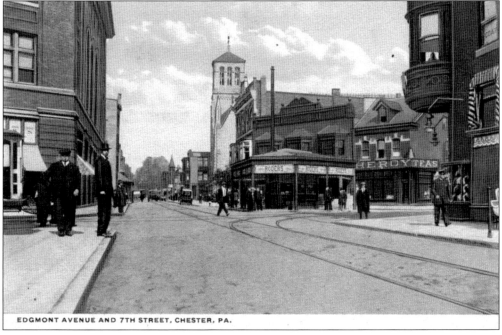

EDGMONT AVENUE AND 7TH STREET, CHESTER, PA.

This is a view of Roders with St. Michael's Church in the background. This image was taken before Coolly Lilly took the place of the tea shop.

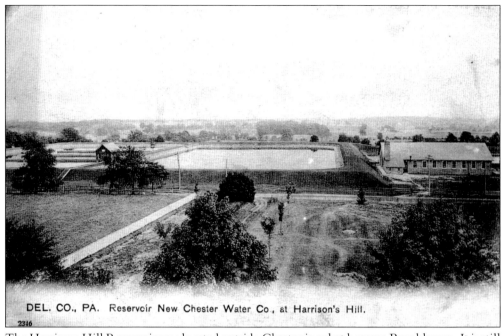

The Harrisons Hill Reservoir was located outside Chester in what became Brookhaven. It is still used by the Chester Water Authority to provide water for Chester and the surrounding area.

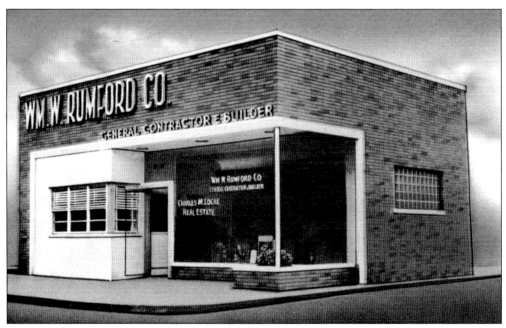

Rumford Contractors, shown here in the 1950s, was originally located at 113 East Eighth Street. William Rumford was the owner.

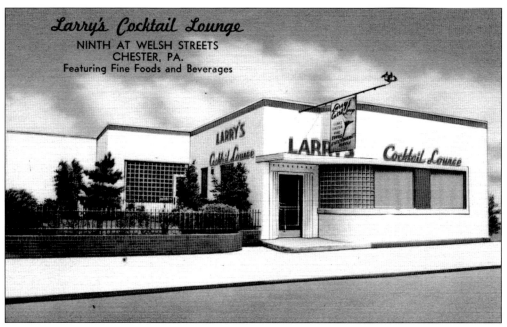

Larry's Cocktail Lounge was located at Ninth and Welsh Streets. It is pictured here around 1947. (Delaware County Historical Society.)

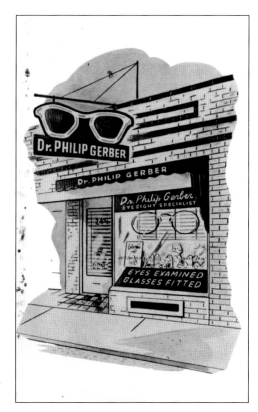

Dr. Philip Gerber, an eye doctor, sent this card to his patients in 1954. (Delaware County Historical Society.)

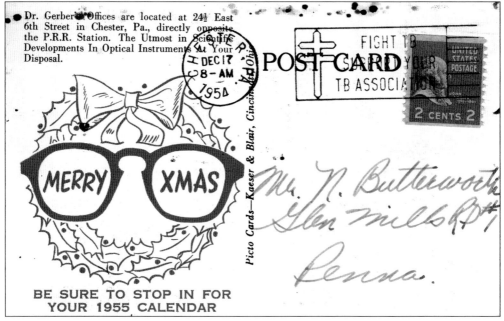

Dr. Gerber's Offices are located at 24½ East 6th Street in Chester, Pa., directly opposite the P.R.R. Station. The Utmost in Scientific Developments In Optical Instruments At Your Disposal.

MERRY XMAS

BE SURE TO STOP IN FOR YOUR 1955 CALENDAR

Picto Cards—Kaeser & Blair, Cincinnati, Ohio

POST CARD

FIGHT TB
TB ASSOCIATION

2 CENTS 2

Mr. N. Butterworth
Glen Mills R#1
Penna.

This is the back of the postcard in the previous view. It reminds patients to get a calendar for the new year. (Delaware County Historical Society.)

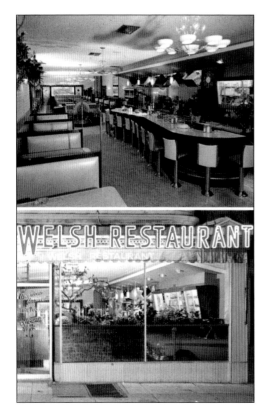

This view of the Welsh Restaurant was taken in the late 1950s. The Welsh Restaurant was located at Seventh and Welsh Streets. (Delaware County Historical Society.)

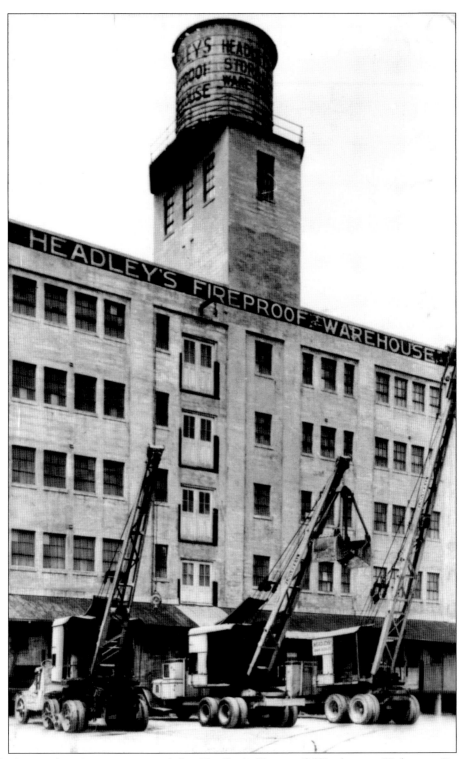

This is an advertisement postcard for Headley's Fireproof Warehouse. (Delaware County Historical Society.)

Chester Baker
Crozier Building
Chester, Pa.

Here is an advertisement sent to Chester Baker, a city civil engineer in Chester, in 1937. (Delaware County Historical Society.)

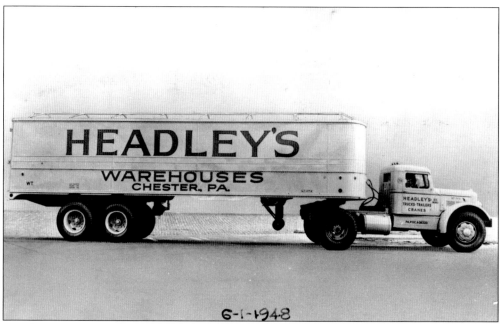

Headley's provided a full range of transfer and storage services. This rig posed for its portrait in 1948. Postwar availability of parts and tires gave this tractor trailer its clean and powerful look. (Delaware County Historical Society.)

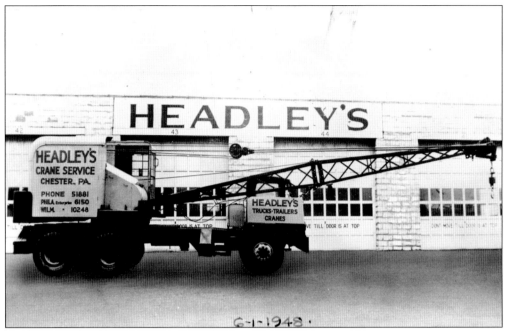

Headley's mobile crane is pictured in 1948. Note the low–digit telephone numbers. (Delaware County Historical Society.)

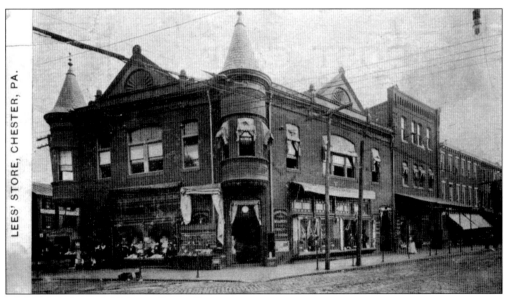

This is a view of Lees' Store, located at Seventh Street and Edgmont Avenue. The store later became the Speare Brothers Department Store. (Delaware County Historical Society.)

There was a time when every home in Chester had a clock such as this Plymouth grandfather clock. (Delaware County Historical Society.)

This is a Tollin's Furniture Store advertisement for Ridgeway Clocks, which was a division of Gravely Furniture Company from Martinsville, Virginia. (Delaware County Historical Society.)

*Style No. 125 — THE PLYMOUTH

Grandfather Clock

The tall (74 in.) PLYMOUTH Clock is a contemporary offering, featuring exquisite detail and design. Balanced proportion and excellence of workmanship make this clock a distinguished acquisition for the most discriminating homemaker.

The polished brass dial with embossed overlays and parquetry on the base front gives an unmatched touch of elegance.

The key wind movement, precision made by West German craftsmen, plays the cheerful Westminster tune progressively on the quarter-hour followed by gonging of the hour.

Here is truly an heirloom of today in Mahogany or Fruitwood (Antique Cherry) finishes.

*Photographed in Fruitwood

TOLLIN'S
615-17 EDGMONT AVE.
CHESTER, PA.

RIDGEWAY CLOCKS . . .
A Division of Gravely Furniture Co., Martinsville, Va.

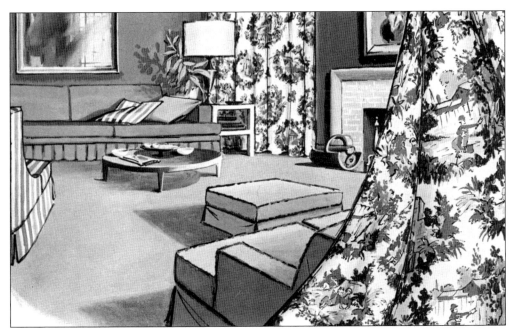

As this image shows, Tollin's provided customers with custom-made slipcovers. (Delaware County Historical Society.)

Pictured here is another advertisement postcard for Tollin's Furniture Store, located at 120–126 East Sixth Street in Chester. (Delaware County Historical Society.)

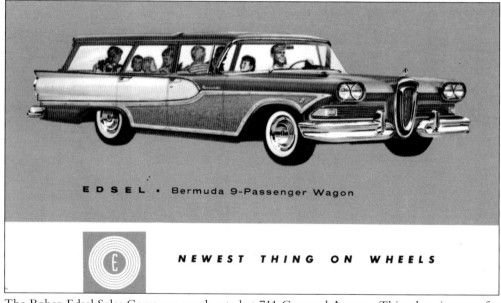

The Boher-Edsel Sales Company was located at 711 Concord Avenue. This advertisement for the Edsel Bermuda nine-passenger wagon boasts that it is "the Newest Thing on Wheels." (Delaware County Historical Society.)

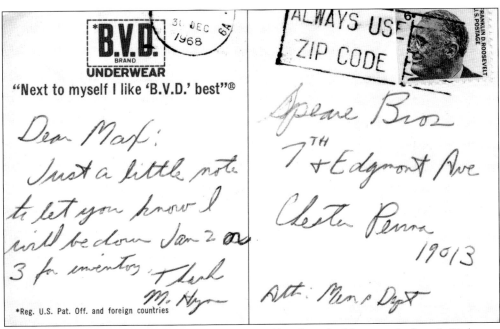

The catchy slogan of "Next to my self I like 'B.V.D.' best" made this a popular brand. (Delaware County Historical Society.)

A PROVEN SELF-SELECTION FIXTURE FOR AMERICA'S PROVEN UNDERWEAR BRAND

This underwear advertisement is for Speare Brothers Department Store. (Delaware County Historical Society.)

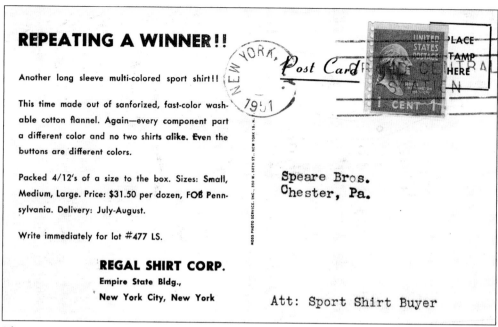

REPEATING A WINNER!!

Another long sleeve multi-colored sport shirt!!

This time made out of sanforized, fast-color washable cotton flannel. Again—every component part a different color and no two shirts alike. Even the buttons are different colors.

Packed 4/12's of a size to the box. Sizes: Small, Medium, Large. Price: $31.50 per dozen, FOB Pennsylvania. Delivery: July-August.

Write immediately for lot #477 LS.

REGAL SHIRT CORP.
Empire State Bldg.,
New York City, New York

Post Card

Speare Bros.
Chester, Pa.

Att: Sport Shirt Buyer

This is a postcard sent to the buyer of Speare Brothers Department Store from the Regal Shirt Corporation. (Delaware County Historical Society.)

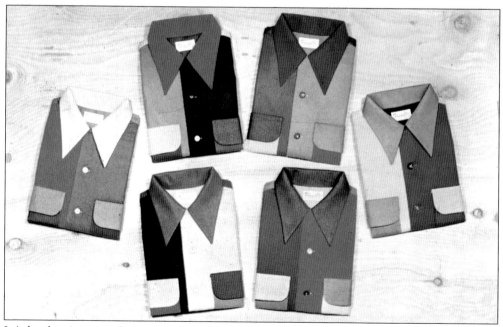

It is hard to imagine that at one time a four-pack of flannel shirts only cost $2.23. (Delaware County Historical Society.)

Four

TRANSPORTATION

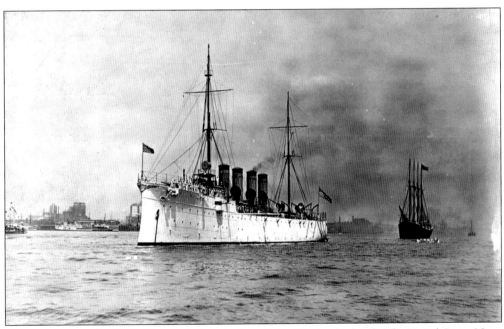

Pictured here is the USS *Chester*. A description of the ship in the book *The United States Navy, From the Revolution to the Present*, published in 1918, reads, "The Light Cruiser Chester. A small, fast cruiser suitable for scouting, the Chester was completed in 1908, displaces 3,570 tons, and has a speed of 28 knots. She carries two five inch guns, and has two torpedo tubes." The launching of the USS *Chester* took place on June 26, 1907. (Delaware County Historical Society.)

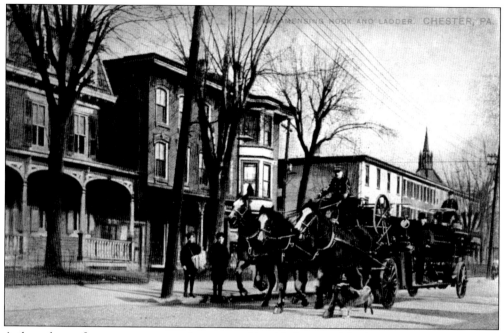

A three-horse fire apparatus runs along an unidentified street. The Moyamensing Hook and Ladder Company had its firehouse at Ninth and Potter Streets, and it was incorporated in February 1870.

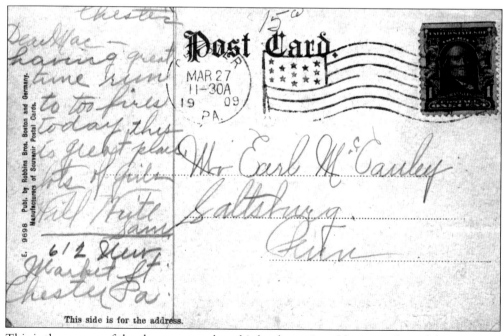

This is the reverse of the above postcard, and it has been signed by a member of the company named Sam, who reports that Chester has "lots of girls." Some things never change.

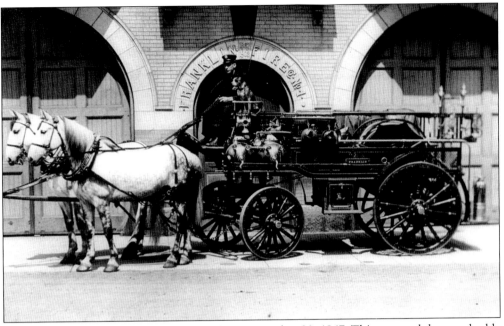

The Franklin Fire Company was founded on November 30, 1867. This postcard shows a double horse-drawn engine posing in front of the firehouse. (Delaware County Historical Society.)

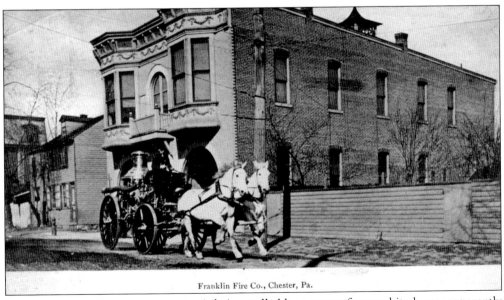

Franklin Fire Co., Chester, Pa.

A Franklin Fire Company apparatus is being pulled by a team of two white horses apparently on the way to a fire.

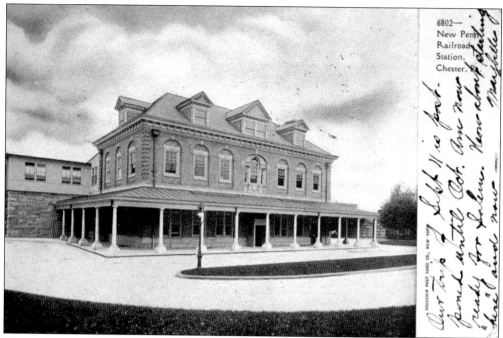

The Pennsylvania Railroad station is located in the center of the city on Sixth Street. The station was built over 100 years ago, and it remains an active transportation hub in Chester.

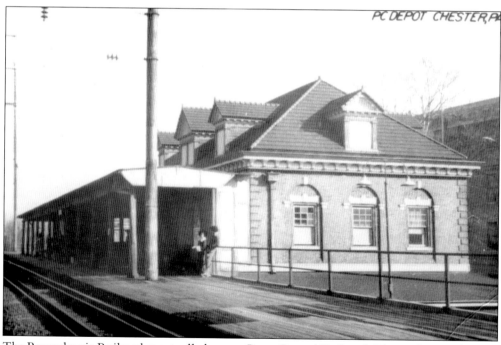

The Pennsylvania Railroad eventually became Penn Central Railroad. The station was located at Sixth Street. After 1906, the tracks were elevated.

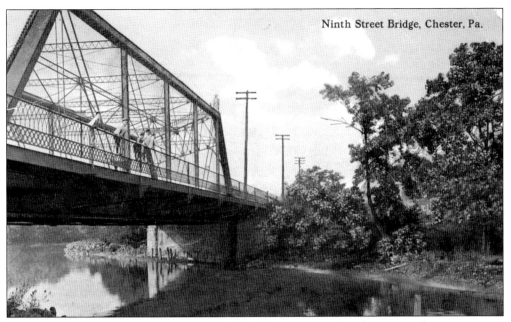

Here is a view of the Ninth Street bridge, which crosses over the Chester Creek.

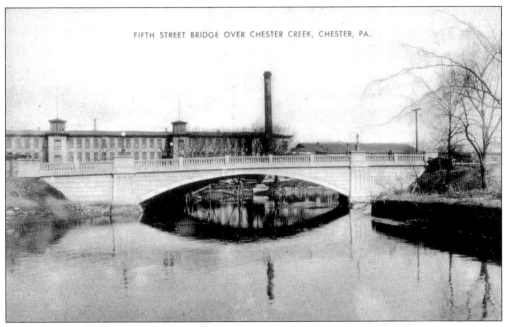

This postcard shows the Third Street bridge crossing over the Chester Creek.

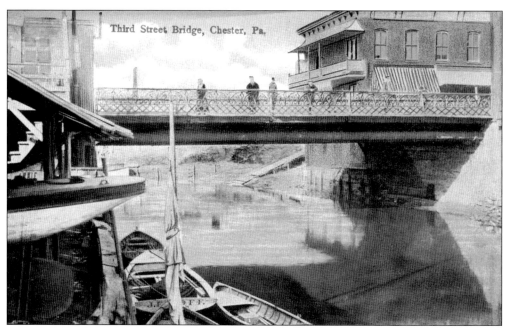

Here is another view of the Third Street bridge and the Chester Creek.

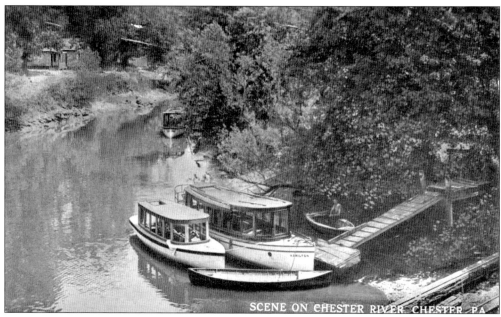

The Chester River, or the Chester Creek, as it is called today, is pictured here. This waterway was navigable up until the late 20th century. This view shows boats on the creek in the early 20th century.

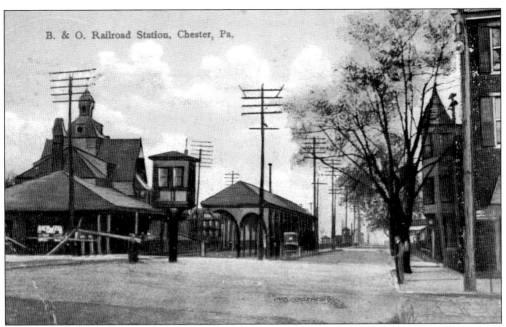

In the 1960s, the Baltimore and Ohio Railroad station was closed. The tracks were relocated to make room for Interstate 95 to go through Chester.

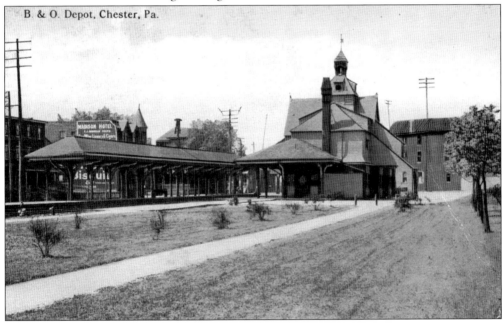

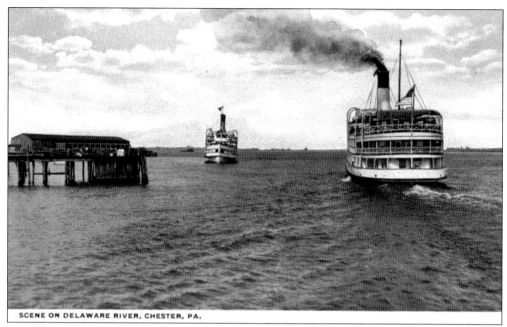

SCENE ON DELAWARE RIVER, CHESTER, PA.

Before cars became the favored way to get around, people used trains and steamboats as their main source of transportation. The steamboats carried people for their daily commute or on a pleasure excursion. Each in its respective channel, ferryboats passed each other constantly, and scenes such as this one were quite common.

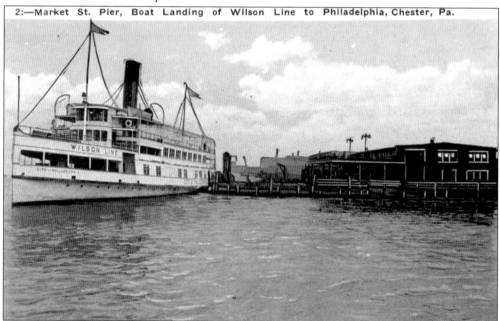

2:—Market St. Pier, Boat Landing of Wilson Line to Philadelphia, Chester, Pa.

The Wilson Line had passenger boats that traveled between Philadelphia, Chester, Wilmington in Delaware, and Riverview Beach in Pennsville, New Jersey. The trips were a popular pastime for people to travel to those destinations. The Wilson Line began in 1882 as the Wilmington Steamboat Company and made excursions until 1961. In the evening, it offered moonlight cruses with live music and dancing.

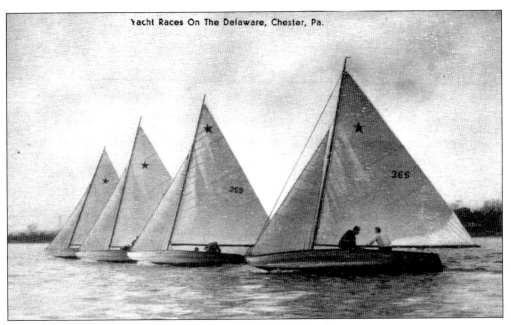

Yacht races on the Delaware River were a popular community event.

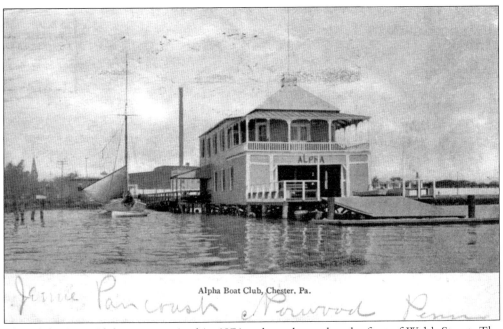

The Alpha Boat Club was organized in 1874 and was located at the foot of Welsh Street. The boat club was removed around 1937 or 1938 in order to make room for the World War II production of liberty ships.

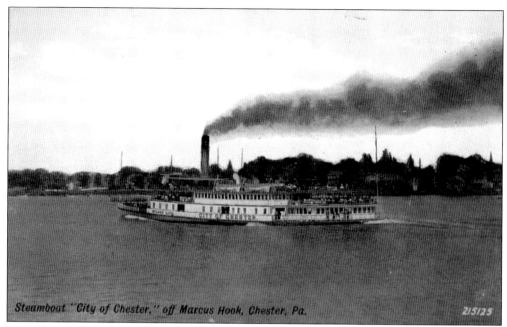

Steamboat "City of Chester," off Marcus Hook, Chester, Pa. 215125

The *City of Chester* steamboat is pictured on the Delaware River. The *City of Chester* was launched with much fanfare on May 2, 1888, at six o'clock in the evening during City of Chester Day celebrations.

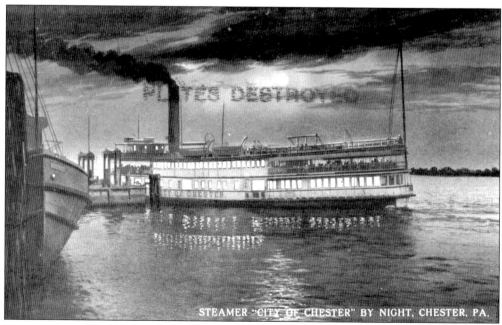

STEAMER "CITY OF CHESTER" BY NIGHT, CHESTER, PA.

The steamboat *City of Chester* is shown on the Delaware River at night. It was the first Delaware River steamer to be equipped with electric lighting.

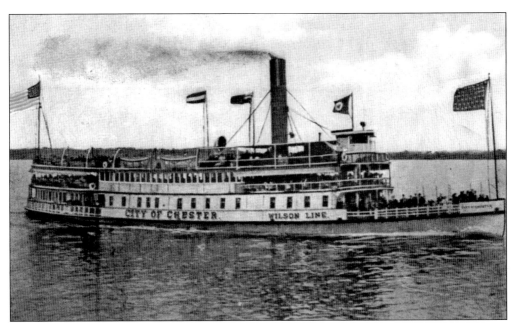

On July 7, 1888, the *City of Chester* made a record-setting time for the trip between Wilmington and Philadelphia of 1 hour and 46 minutes, including a 6-minute stop in Chester. (Delaware County Historical Society.)

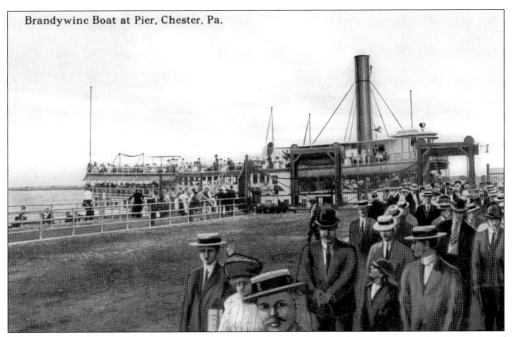

The steamer *Brandywine* is pictured at the pier on the Delaware River in the city of Chester. The *Brandywine* was considered the best icebreaker on the river. (Delaware County Historical Society.)

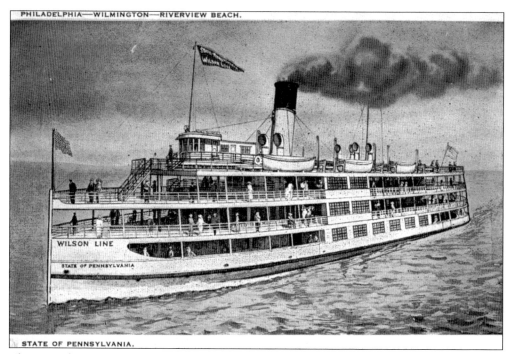

WILSON LINE

STATE OF PENNSYLVANIA.

STATE OF PENNSYLVANIA.

The *State of Pennsylvania* was the last steamer built exclusively for Delaware River traffic. Trials of the new ship were made on July 12, 1923, and it made its first trip out of Philadelphia on July 15, 1923. (Delaware County Historical Society.)

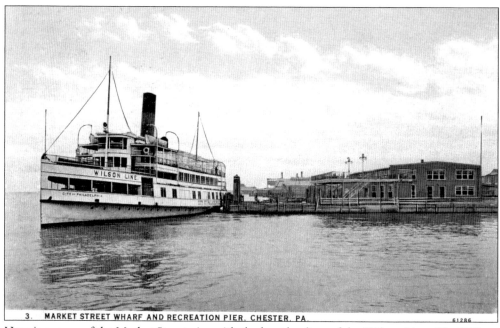

WILSON LINE

3. MARKET STREET WHARF AND RECREATION PIER, CHESTER, PA. 61286

Here is a scene of the Market Street pier with the boat landing of the Wilson Line. The Wilson Line began in 1882 as the Wilmington Steamboat Company and made excursions until 1961. (Delaware County Historical Society.)

Walking Through Chester

TUNE—Marching Through Georgia.

PRICE, ONE CENT.

Don't forget the Strikers, boys,
 Just help them push along;
Help them with a spirit
 That will show the company's wrong,
Help them as we started to,
 No matter then how long
While we are walking through Chester.

CHORUS:
Hurrah! hurrah! the strikers they are it,
Hurrah! hurrah! the trolleys are hard hit;
To ride their cars would lower us, boys,
And that won't do at all,
 While we are walking through Chester

Then here is to the Union men
 And they need have no fears,
People see non Union men
 But give them only jeers;
Let us give the Strikers, boys,
 Three times a hundred cheers
While we are walking through Chester.

CHORUS:
Hurrah! hurrah! the Strikers they are it,
Hurrah! hurrah! the trolleys are hard hit;
To use their cars would lower us, boys,
And that won't do at all
 While we are walking through Chester.

"Walking through Chester" was used as a strike song during the long trolley strike of 1908. It was sung to the tune of "Marching through Georgia."

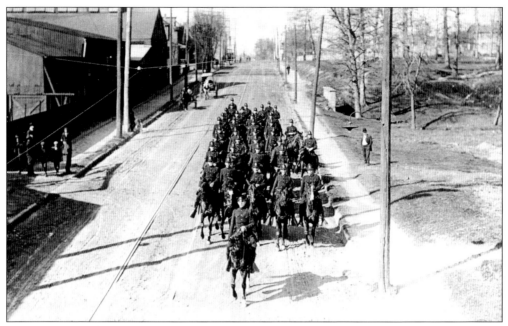

The state constabulary enters from the southwest on Seventh Street from the Broomall Street bridge. They were sent to Chester from Reading to guard the cars and property of the Chester Traction Company from vandalism by trolley company employees. (Delaware County Historical Society.)

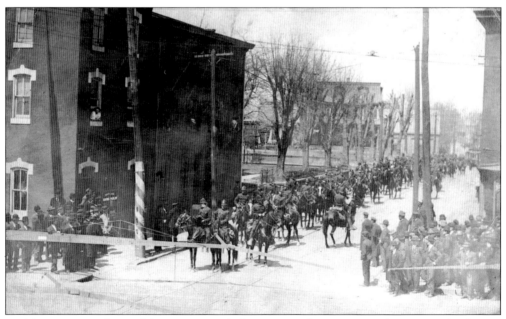

In this scene, members of the state constabulary enter Chester on April 17, 1908. (Delaware County Historical Society.)

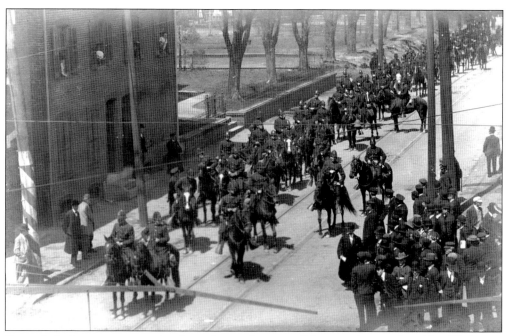

Constabularies are seen entering from the northwest on Edgmont Avenue from Twelfth Street. (Delaware County Historical Society.)

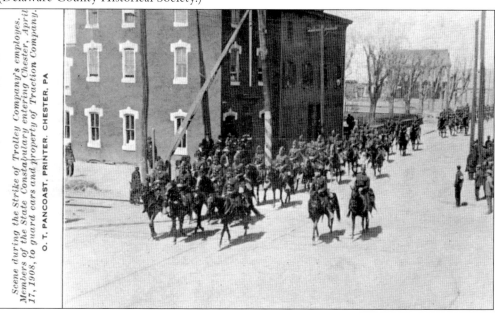

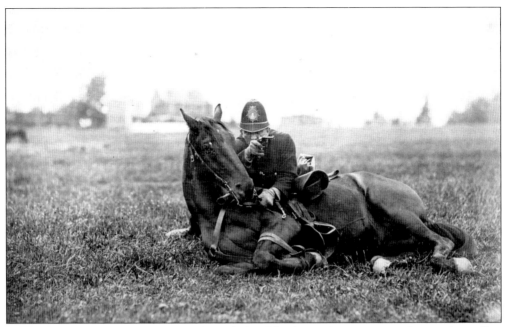

A member of the state constabulary hides behind his horse for protection during the trolley strike in 1908 on the lawn of the Alfred O. Deshong estate. This view was taken from the northwest looking toward Twelfth Street. (Delaware County Historical Society.)

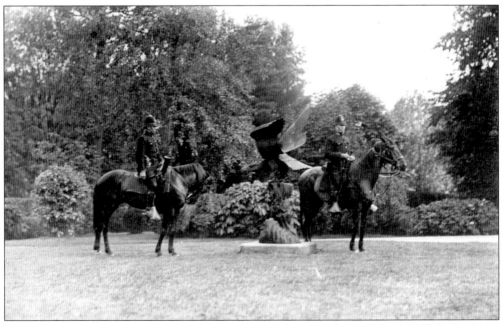

A group of state constabulary officers observe events from the lawn of the Alfred O. Deshong estate during the 1908 trolley strike. (Delaware County Historical Society.)

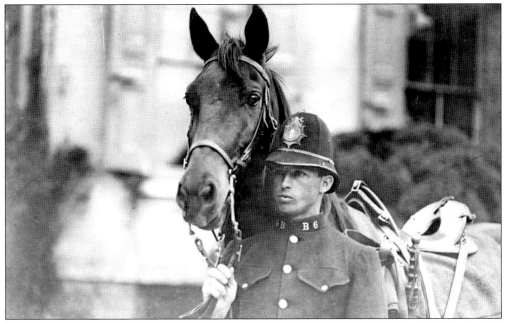

Here a state constabulary officer is seen holding his horse in front of the Deshong mansion during the 1908 trolley strike. (Delaware County Historical Society.)

This southwest view was taken from the Second Street bridge during the 1908 trolley strike. (Delaware County Historical Society.)

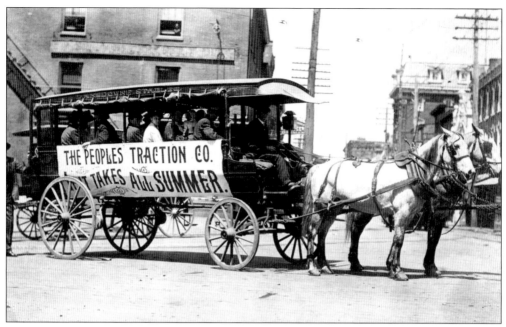

The sheriff and citizens of Chester had sympathy for the strikers, and they took the inconvenience in stride, finding their own ways of getting around. This photograph was taken at Market Square. (Delaware County Historical Society.)

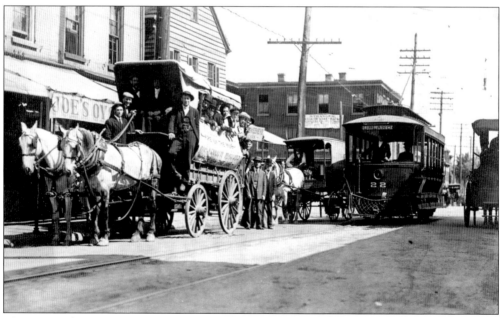

This is a southwest view of the trolley cars looking toward Market Square from Market Street during the trolley strike. (Delaware County Historical Society.)

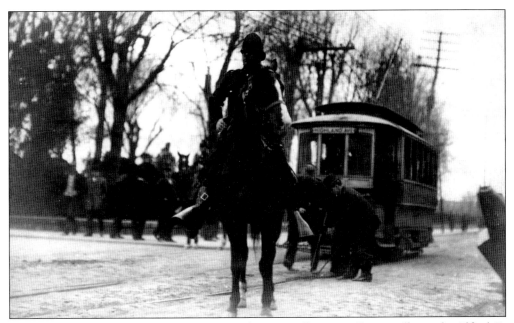

This northwest view from Edgmont Avenue shows an officer guarding a trolley at the Alfred O. Deshong mansion gate while replacement workers clear an obstructed rail. (Delaware County Historical Society.)

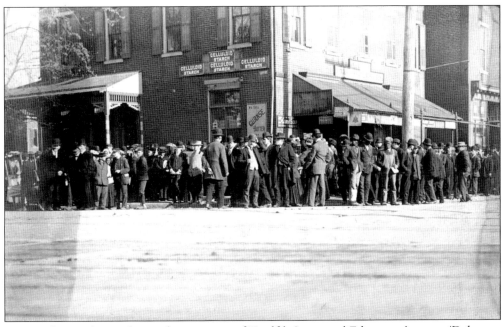

Here strikers gather at the southeast corner of Twelfth Street and Edgmont Avenue. (Delaware County Historical Society.)

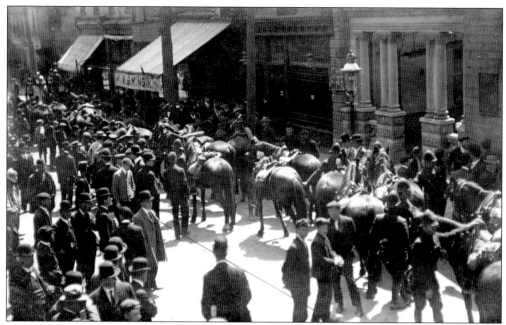

People gather south of the Washington House on Market Street between Fourth and Fifth Streets at the columns between city hall (the 1724 courthouse) and Pennsylvania National Bank. (Delaware County Historical Society.)

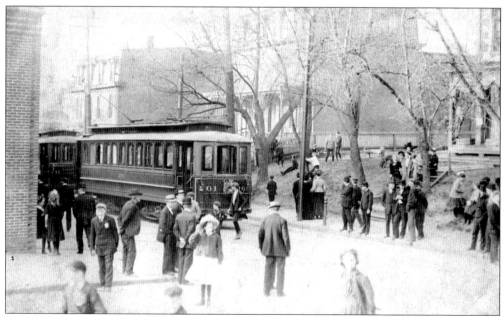

Trolleys are pictured at a standstill as people gather on the street during the strike of 1908. (Delaware County Historical Society.)

Five

INDUSTRY

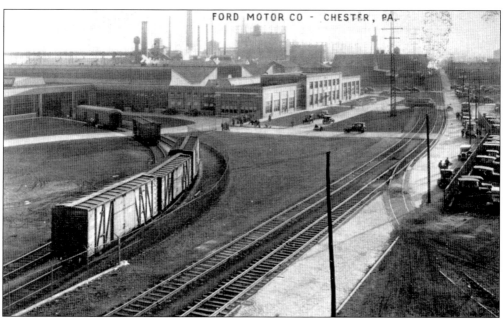

The Ford Motor Company assembly plant was built in 1925. The plant was constructed on a 50-acre site on the former Roach's Shipyard and Merchant Ship Building Corporation located on Front Street from Fulton to Pennell Streets.

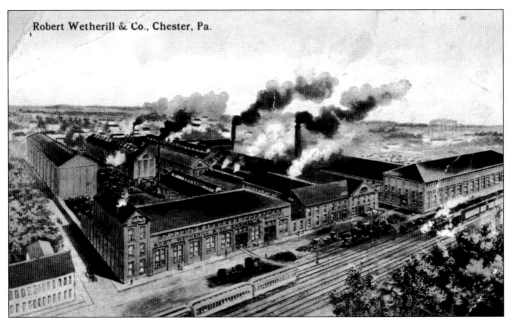

Robert Wetherill and Company was founded in 1872. Wetherill manufactured the Corliss steam engine. The building, located at Sixth and Upland Streets, was destroyed by fire on April 2, 2002.

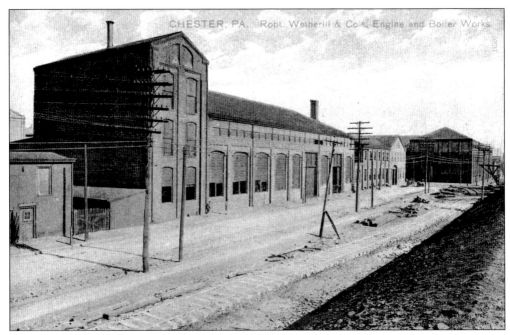

Here is a view of the boiler works at Robert Wetherill and Company.

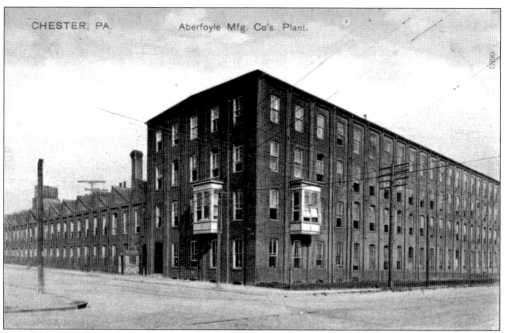

Aberfoyle Manufacturing Company was started in 1883 by William T. Galey. It occupied a four-story building fully equipped with the most improved dying, weaving, and finishing machinery for the production of fine textile fabrics. It specialized in high-grade fancy cotton goods, worsted yarns, merino yarns, silk yarns, and linens.

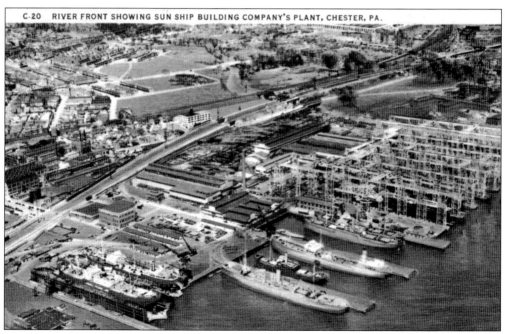

C-20 RIVER FRONT SHOWING SUN SHIP BUILDING COMPANY'S PLANT, CHESTER, PA.

Known in Chester simply as Sun Ship, the Sun Ship Building and Drydock Company was founded in 1916.

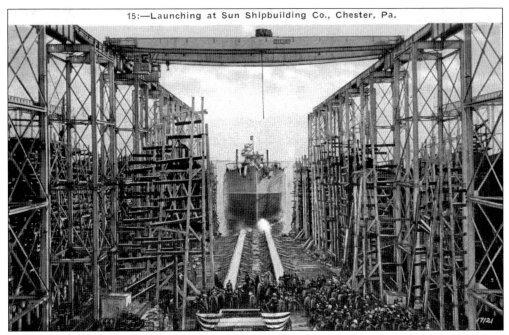

The first ship built by Sun Ship Building and Drydock Company was the SS *Chester Sun* in 1917. The original site for the company was 64 acres, and it contained 36 buildings. Many important ships were built there during World War II. Today it is the site of Harrah's racetrack and casino.

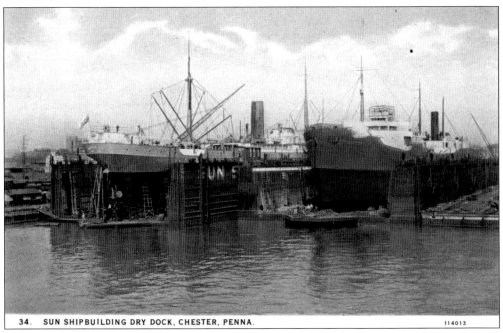

34. SUN SHIPBUILDING DRY DOCK, CHESTER, PENNA.

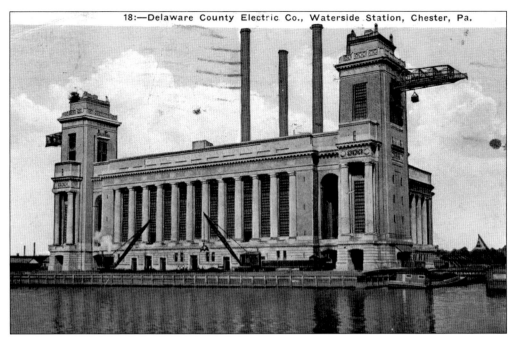

The Delaware County Electric Company generating station opened in 1918. The plant closed around 1980. It is located between Highland Avenue and the Commodore Barry Bridge. It has been restored and made into offices.

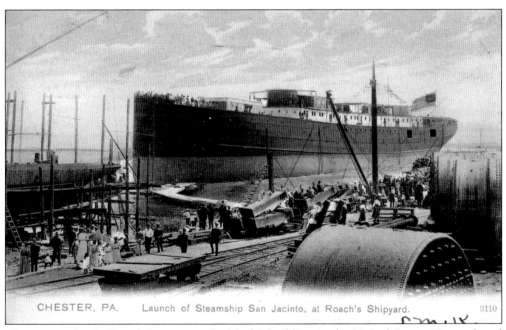

CHESTER, PA. Launch of Steamship San Jacinto, at Roach's Shipyard. 3110

The name John B. Roach is connected with shipbuilding in the United States. He purchased the former Reaney Son and Archibald Shipyard in Chester in 1871. In 1887, Roach was elected president of the Delaware River Iron Shipbuilding and Engine Works. The Roach family home was located at Eighth and Kerlin Streets in Chester.

77

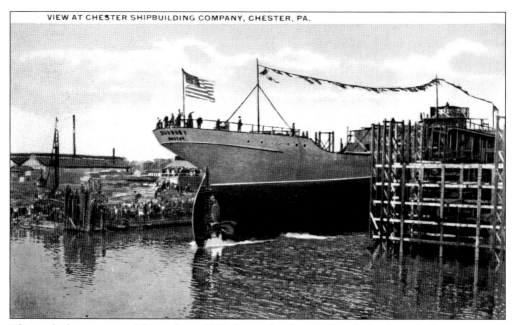

This real-photo postcard from about 1918 shows the ship *Sudbury* being launched.

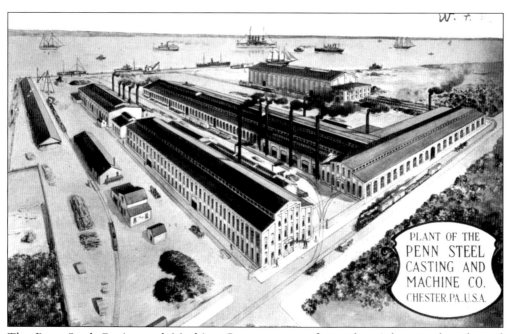

PLANT OF THE
PENN STEEL
CASTING AND
MACHINE CO.
CHESTER.PA.,U.S.A.

The Penn Steel Casting and Machine Company manufactured mainly open-hearth steel castings. A fire damaged the plant on February 27, 1970.

Six

Parks and Historic Sites

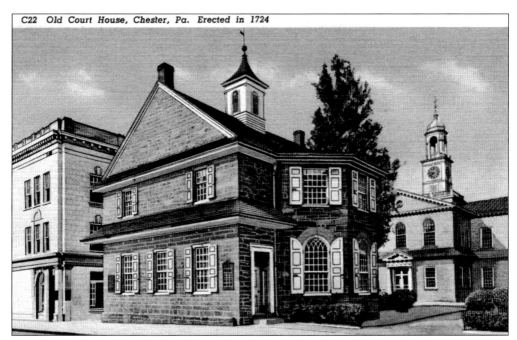

Built in 1724 during the reign of King George I of England, this is the oldest government building in continuous use in the United States.

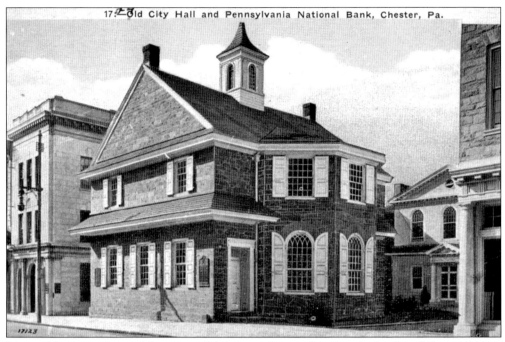

Pictured here are views of the restored 1724 courthouse, showing the bank building, which is now home of the Delaware County Historical Society. (Delaware County Historical Society.)

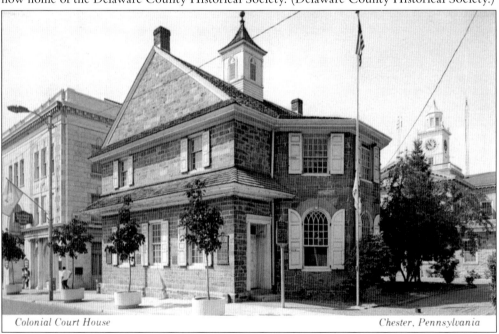

Colonial Court House *Chester, Pennsylvania*

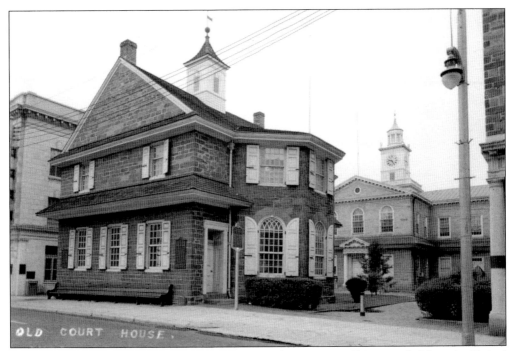

Marquis de Lafayette was honored here in 1824 on the occasion of his second visit to the United States. The courthouse is located on the Avenue of the States between Fourth and Fifth Streets. (Delaware County Historical Society.)

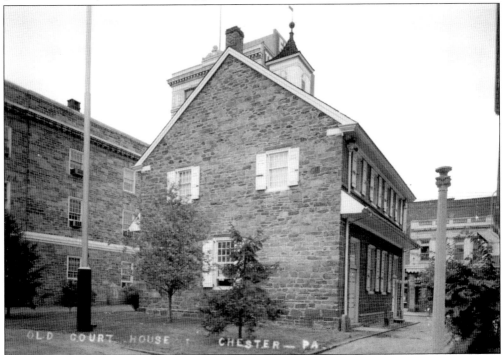

It was on this ground behind the courthouse that "Mad Anthony" Wayne, so called because of his reckless exploits, drilled Continental troops in 1776. (Delaware County Historical Society.)

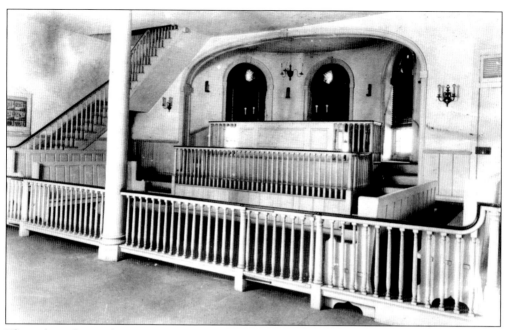

The color scheme that was intended to be applied to the courthouse's interior during the restoration had to be changed when traces of the original 18th-century paints were discovered. (Delaware County Historical Society.)

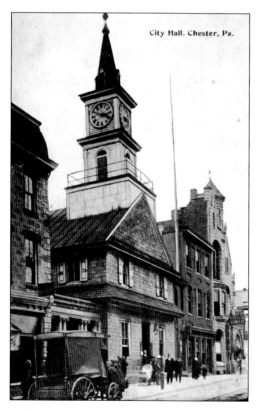

This is an exterior view of the 1724 courthouse. In 1851, it became the new city hall of Chester when the county seat was moved to Media. (Delaware County Historical Society.)

This is a Victorianized view from the early 1900s of the 1724 courthouse that was used as Chester City Hall.

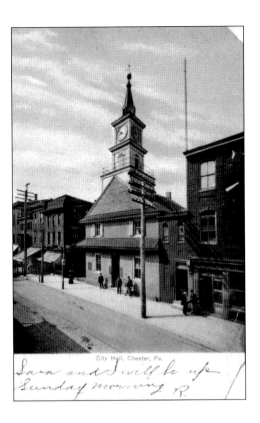

The new city hall later became the police station. It is now awaiting rehabilitation and restoration.

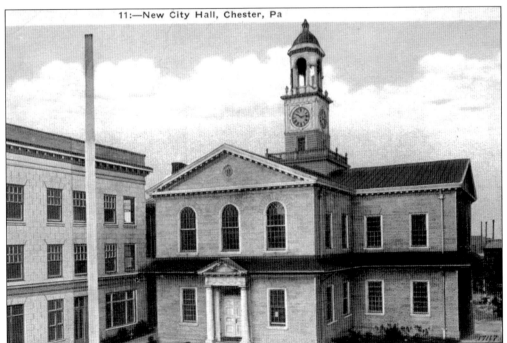

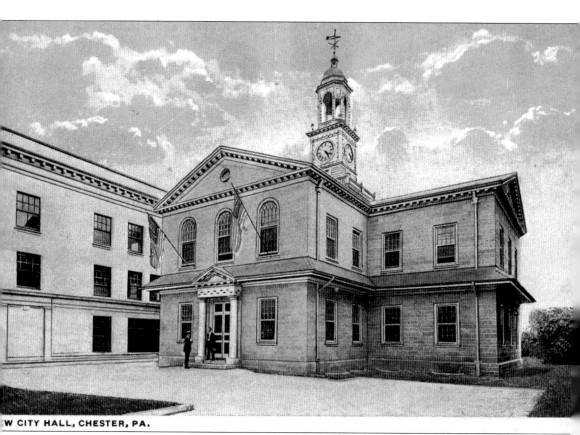

The new city hall was built in the 1920s to house the local government. The building was designed by Clarence Brazer to look Colonial.

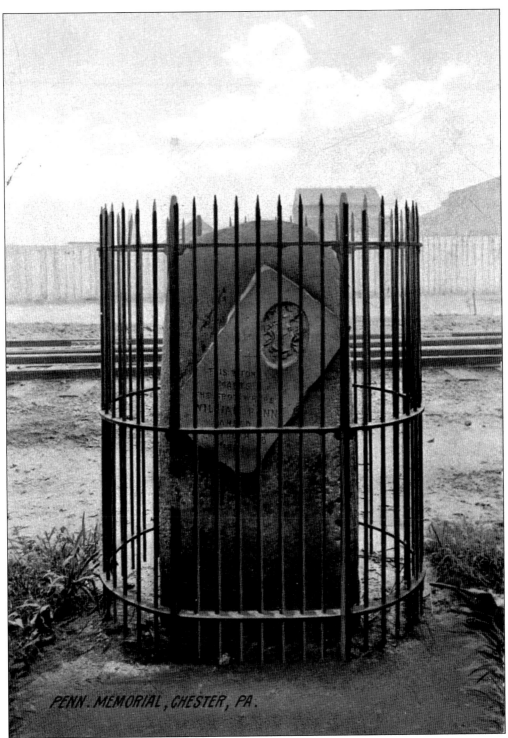

PENN. MEMORIAL, CHESTER, PA.

The William Penn monument was dedicated in 1882 in honor of Penn's arrival on October 28 and 29, 1682, to his new colony, now known as Pennsylvania. This exact site was the birthplace of the state of Pennsylvania.

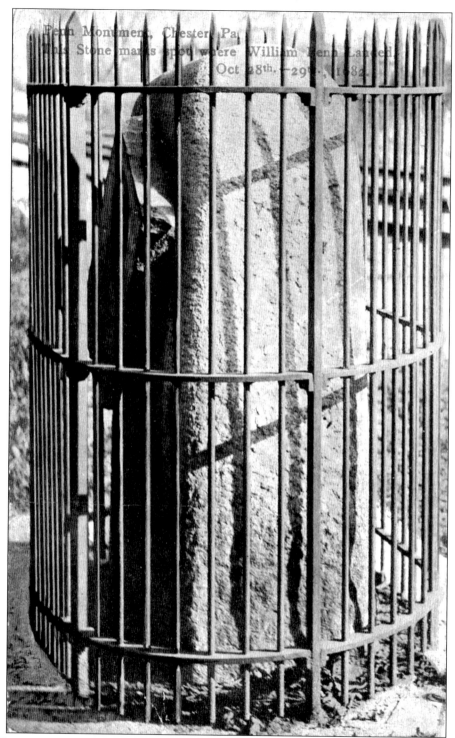

William Penn arrived on his ship called the *Welcome*, which was anchored in the Delaware River. He stayed at the home of Robert Wade, the Essex House, which was formerly the farmstead of Gov. John Printz's daughter.

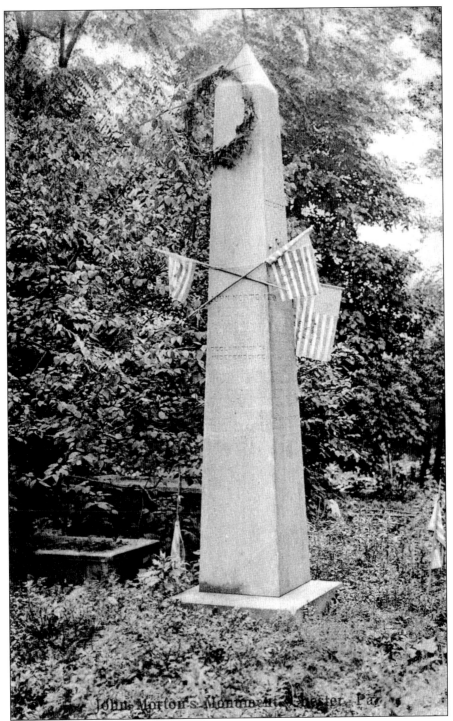

Depicted above is the grave site of John Morton. His vote was the tiebreaker for the Declaration of Independence. Morton was the only delegate to the Continental Congress from Delaware County, formally Chester County. Many people reviled him for signing the Declaration of Independence. He died within a year of the signing of the document.

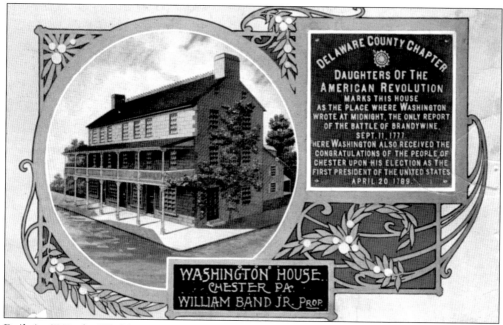

Built in 1747, the Washington House stood across Market Street (now known as the Avenue of the States) from the 1724 Colonial courthouse. It was a frequent stopping place for George Washington on his travels between Philadelphia and Mount Vernon, Virginia. He wrote his report on the battle of Brandywine for Congress here on September 11, 1777. Benjamin Franklin stayed here in 1764 on his way to France. (Delaware County Historical Society.)

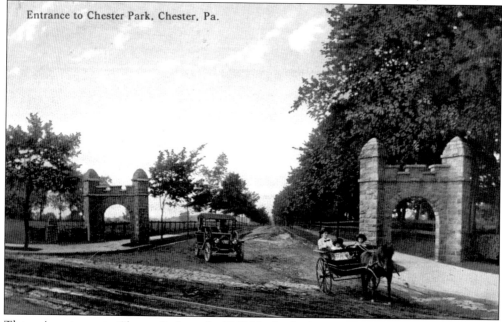

The main entrance to Chester Park on the 2500 block of Edgmont Avenue is pictured here. The parkland was donated to the city by Edward Dickerson. The entrance arches were designed by Theophilus Chandler. There are 46 acres of parkland, which include tennis courts and a band shell. The Ridley Creek runs through the park.

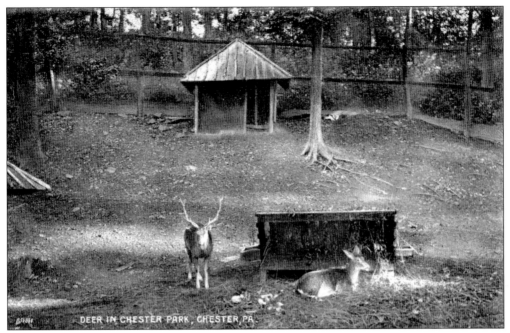

Shown here is a postcard of deer in Chester Park. In 1900, a zoo was located in the park, and these deer were part of the animal attractions.

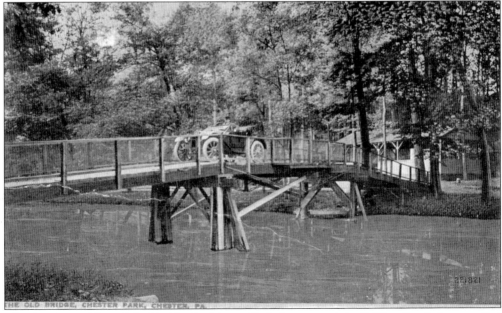

This is a view of the original bridge in Chester Park that crossed the Ridley Creek. It was called the "ladies bridge," as the funds to build it were raised by the women of Chester.

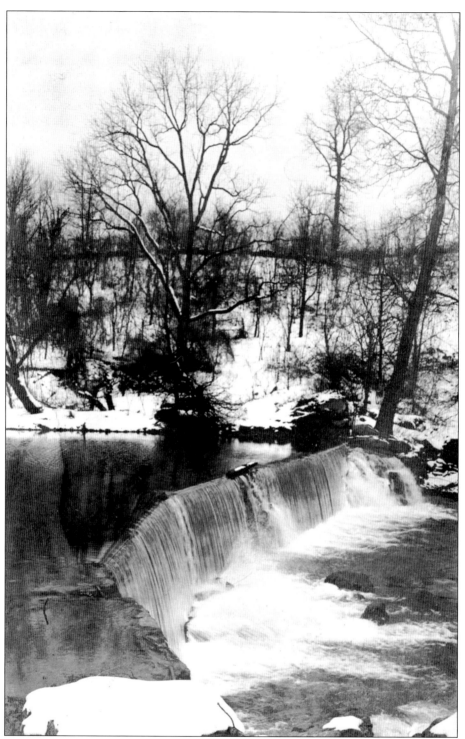

This postcard depicts the waterfall in Chester Park. This waterfall was erected to make a deep area in the creek suitable for rowboating. It was dismantled in 2005 to bring the creek back to its previous depth and original path.

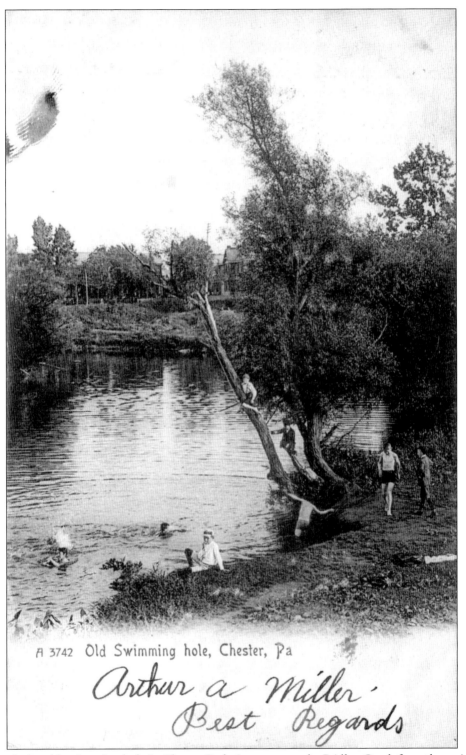

A 3742 Old Swimming hole, Chester, Pa

Arthur a Miller · Best Regards

Here is the old swimming hole in Chester Park. It was across the Ridley Creek from the spring. There was a rock at this location that swimmers used to dive into the water.

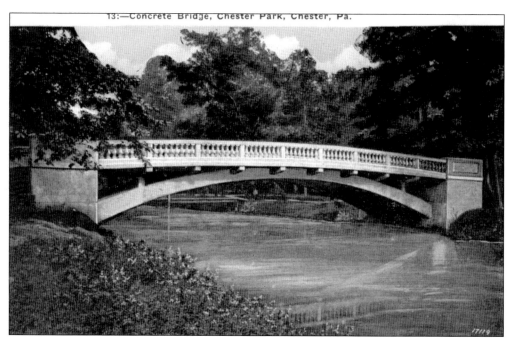

13:—Concrete Bridge, Chester Park, Chester, Pa.

This new bridge in Chester Park replaced the original ladies bridge. It was constructed later to enable traffic to traverse both ways across the Ridley Creek. (Delaware County Historical Society.)

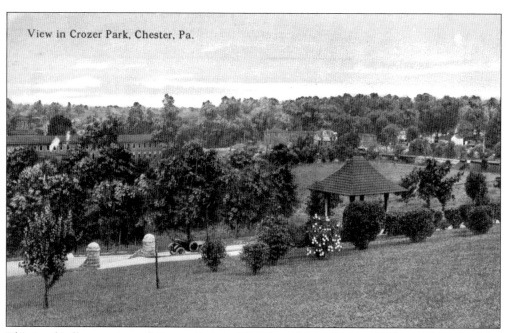

View in Crozer Park, Chester, Pa.

This is a bird's-eye view of Crozer Park looking from Upland toward Chester. This land for the park, which was 30 acres, was donated by Samuel A. Crozer on July 14, 1894. The park was named Crozer Park in honor of him.

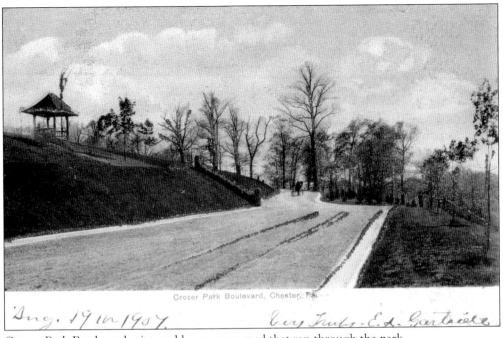

Crozer Park Boulevard, pictured here, was a road that ran through the park.

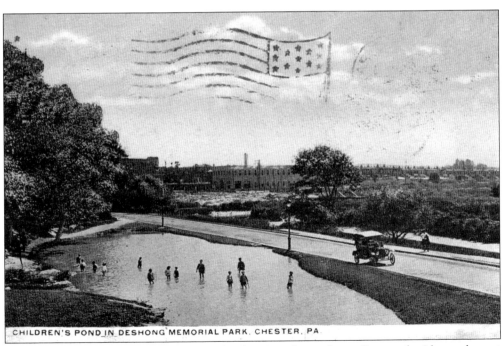

In Deshong Park there was a wading pool. This view shows the wading pool with people next to Deshong Boulevard.

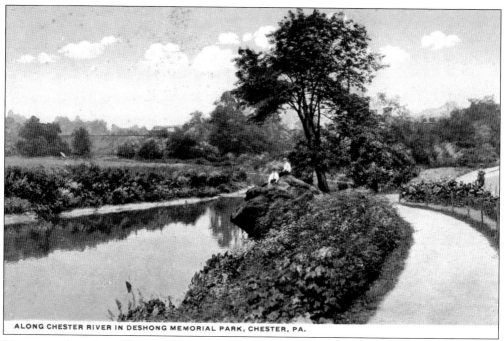

ALONG CHESTER RIVER IN DESHONG MEMORIAL PARK, CHESTER, PA.

Here is another view of Deshong Boulevard showing its proximity to the Chester River.

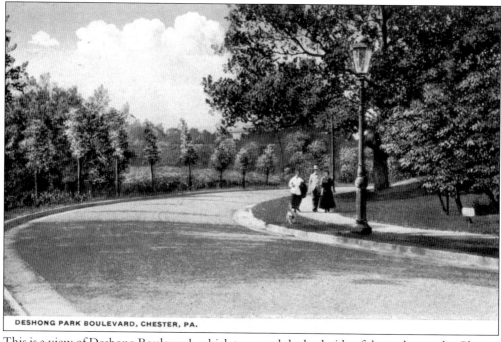

DESHONG PARK BOULEVARD, CHESTER, PA.

This is a view of Deshong Boulevard, which traversed the back side of the park near the Chester River. It connected Ninth Street with Eighth Street.

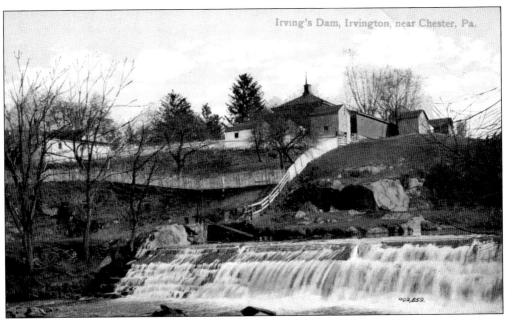

The Irving dam was located in an area called Irvington. This area is now part of the First Ward in Chester known as Irvington Hills. There was originally a mill located on the section of the Ridley Creek, and the dam provided waterpower for the mill.

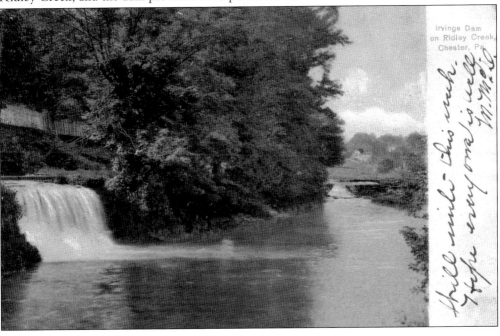

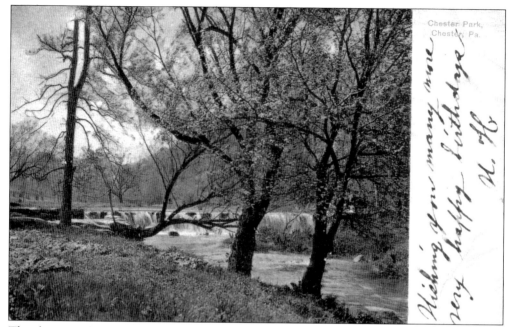

The dam in Chester Park, which is located below the bridge, is shown here. It has since been demolished.

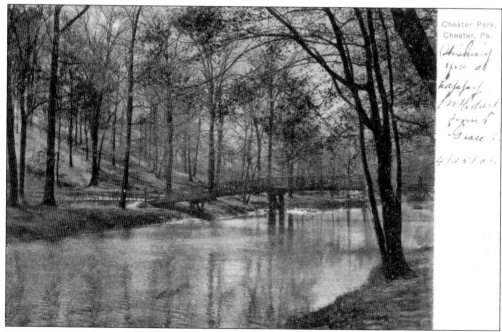

Here is another view of the old bridge in Chester Park over the Ridley Creek.

Seven

Hotels and
Public Buildings

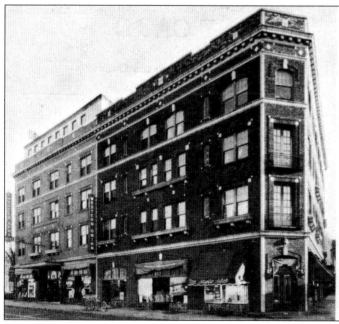

THE CHESTER ARMS is located at Fourth and Edgmont Avenue, Chester, Pa. Chester is one of Pennsylvania's busy industrial centers, on the Delaware River, fifteen miles southwest of Philadelphia. The main highway—U. S. No. 13—through Philadelphia, New York, and points north, and thru Wilmington, Baltimore, Washington, and points south, passes through Chester. The Chester Arms is conveniently located for those who travel this highway. Here you will find comfortable lodging, good food, and reasonable prices.

F. M. Scheibley
Management

The Chester Arms Hotel, located at Fourth Street and Edgmont Avenue, was very popular in its heyday from the 1930s until the 1950s, and it is still standing today. Edgmont Avenue was the first street laid out in 1686 "by the authority of the Grand Jury."

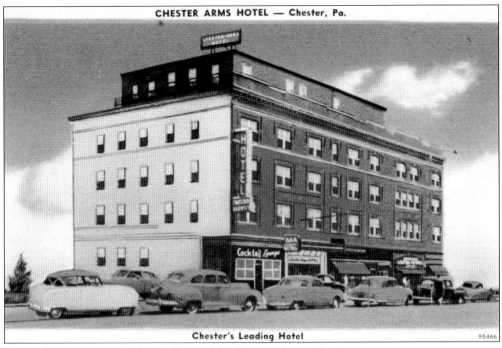

Shown here are two additional views of the Chester Arms Hotel.

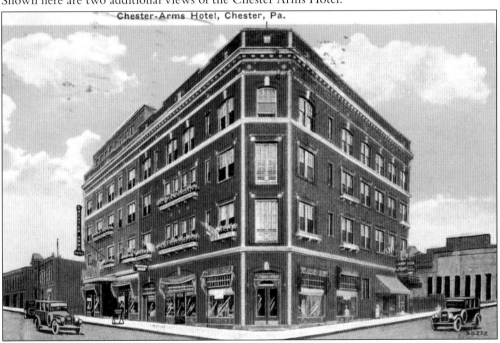

98

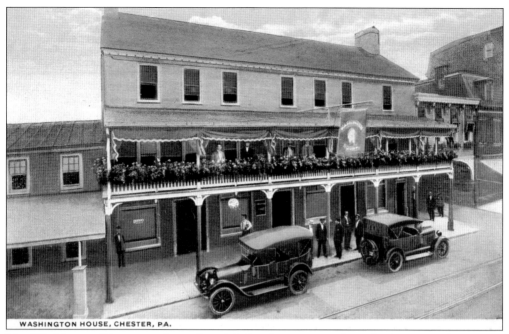

WASHINGTON HOUSE, CHESTER, PA.

The Washington House was located on Market Street across from the 1724 courthouse. On September 11, 1777, George Washington wrote to Congress regarding the battle of Brandywine from the Washington House.

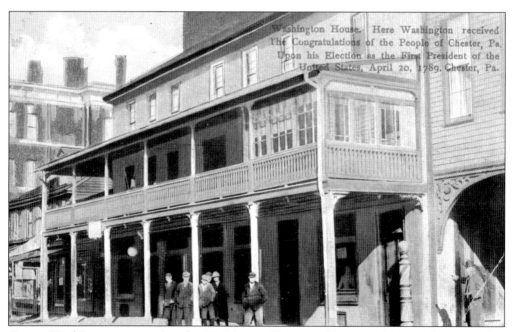

Washington House. Here Washington received The Congratulations of the People of Chester, Pa. Upon his Election as the First President of the United States, April 20, 1789. Chester, Pa.

George Washington returned to the Washington House on his way to New York on Monday, April 20, 1789, to be inaugurated as the first president of the United States.

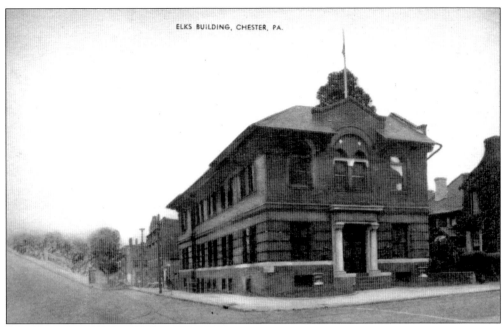

The Elks building is located at the corner of Fifth and Welsh Streets. It originally housed the Elks lodge, and more recently, the building was used as the city hall annex.

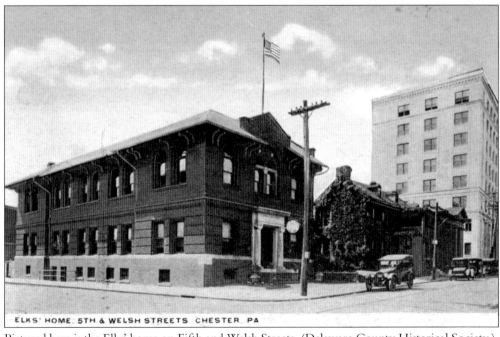

Pictured here is the Elks' home on Fifth and Welsh Streets. (Delaware County Historical Society.)

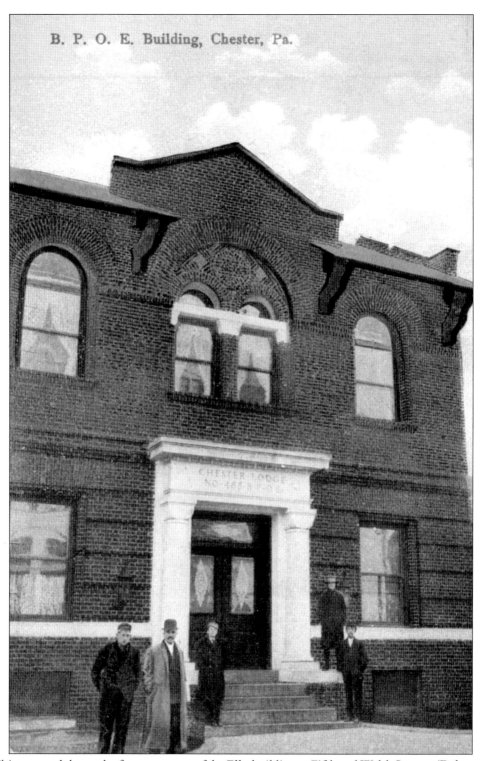

B. P. O. E. Building, Chester, Pa.

This postcard shows the front entrance of the Elks building at Fifth and Welsh Streets. (Delaware County Historical Society.)

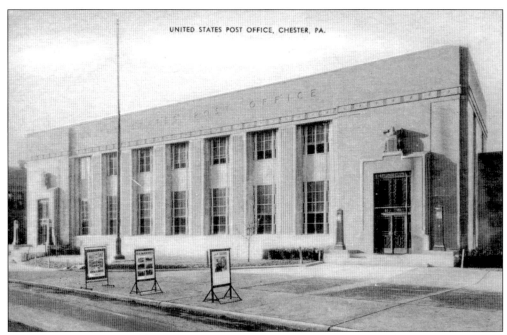

UNITED STATES POST OFFICE, CHESTER, PA.

The new Chester Post Office was built in the 1930s under the auspices of the Works Progress Administration (WPA). The exterior of the building was constructed as a beautiful art deco structure with elaborate brass doors. The interior was decorated with beautiful murals.

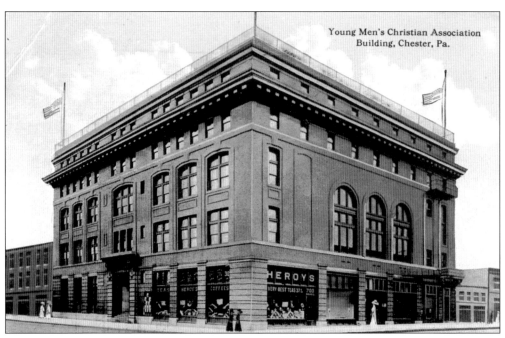

Young Men's Christian Association Building, Chester, Pa.

The old YMCA building was located at Seventh Street and Edgmont Avenue. The YMCA was formed in 1860 by Samuel A. Crozer, who became its first president. In 1907, the YMCA moved into this building.

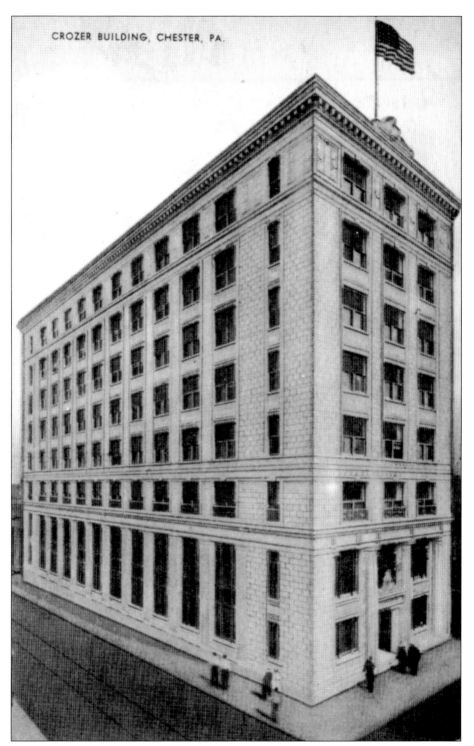

CROZER BUILDING, CHESTER, PA.

The Crozer building is located at 419 Avenue of the States. It was built in 1916, and it was Chester's only skyscraper at the time. Many insurance companies have had their offices in the building over the years.

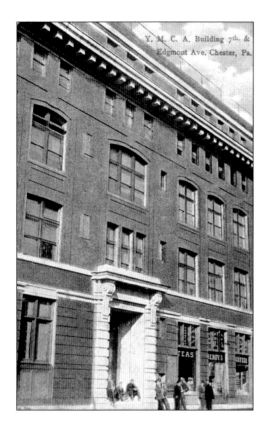

This is a front view of the old YMCA building. The YMCA moved out of this building in 1956. (Delaware County Historical Society.)

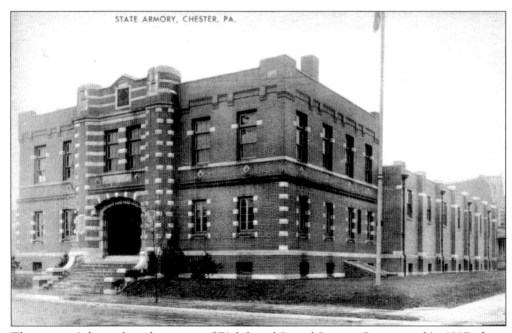

The armory is located on the corner of Eighth and Sproul Streets. Constructed in 1907 after a fire destroyed the armory on Fifth Street, it was in service until about 1956.

This is another view of the armory. (Delaware County Historical Society.)

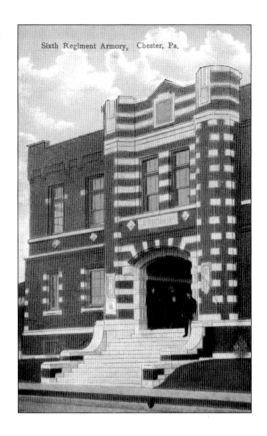

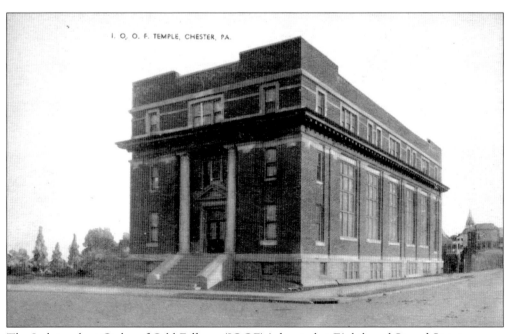

The Independent Order of Odd Fellows (IOOF) is located at Eighth and Sproul Streets.

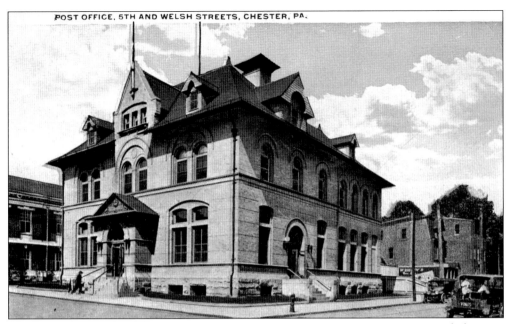

POST OFFICE, 5TH AND WELSH STREETS, CHESTER, PA.

The old Chester Post Office, located at Fifth and Welsh Streets, was in use until the new post office was opened in the 1930s. The building became city hall when the new post office was erected.

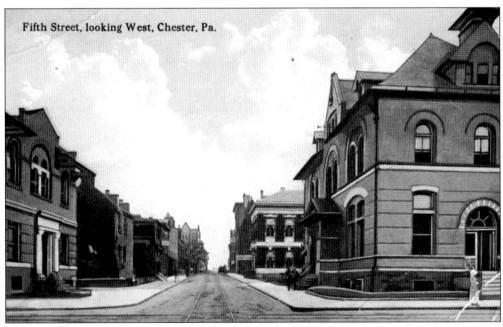

Fifth Street, looking West, Chester, Pa.

Here is a view of Fifth Street looking west from Welsh Street. The old post office can be seen to the right and the Elks building on the left.

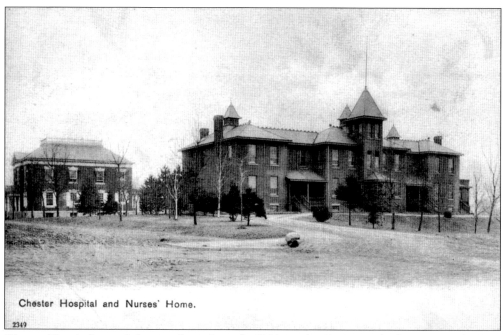

Chester Hospital and Nurses' Home.

2349

Chester Hospital served the area from the early 1800s to the 1960s, at which time it underwent a merger with Crozer. It then became the Crozer-Chester Medical Center. (Delaware County Historical Society.)

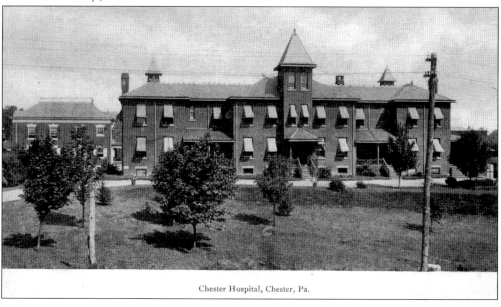

Chester Hospital, Chester, Pa.

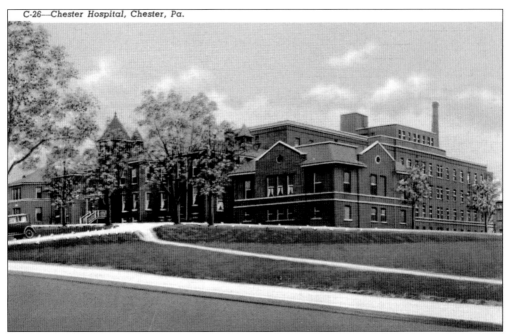

Here is an additional view of Chester Hospital. This location later became the home of the new Chester High School. (Delaware County Historical Society.)

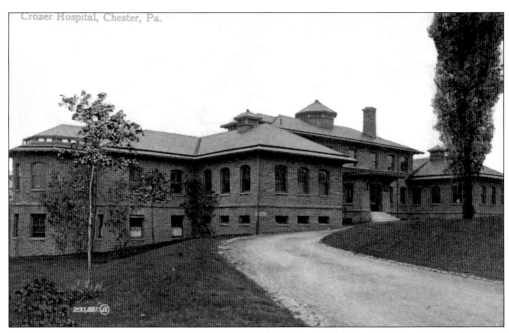

Crozer Hospital, Chester, Pa.

This is a view of Crozer Hospital that was erected in 1903 by Mrs. J. Lewis Crozer at her own expense. The current Crozer-Chester Medical Center had its beginning in this building.

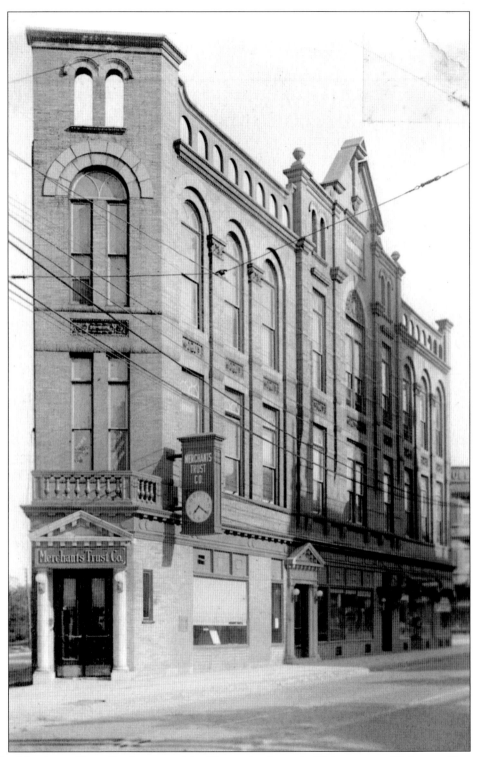

The Merchants Trust Bank operated in Chester in the early 20th century. (Delaware County Historical Society.)

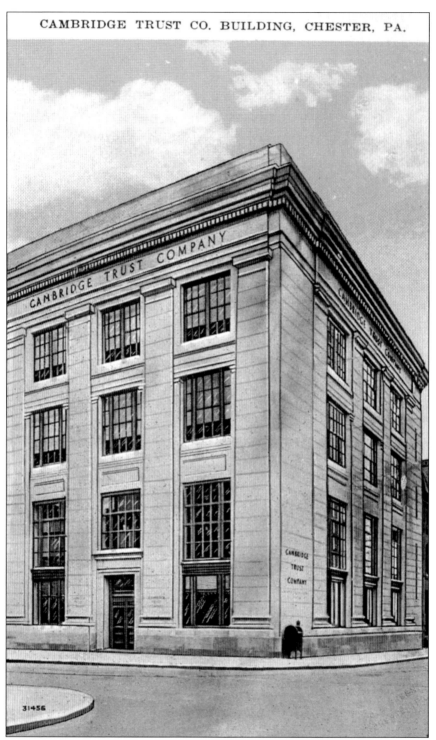

CAMBRIDGE TRUST CO. BUILDING, CHESTER, PA.

This was the original location of the Colonial Hotel at the corner of Fifth and Market Streets. Following its demolition, the Cambridge Hotel was erected. Later the building became the Cambridge Trust Company. (Delaware County Historical Society.)

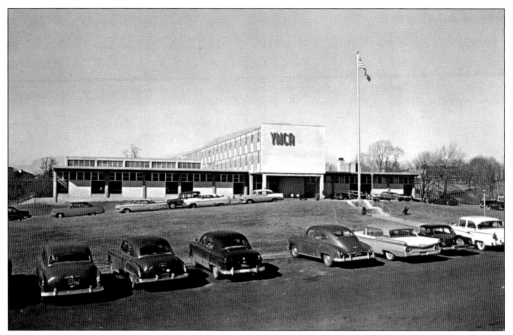

The YMCA in Eyre Park was a one-story structure built in the 1950s. This is a view of the John G. Pew YMCA building, located at 2 South Eyre Park Drive. The dedication for this building took place on September 23, 1956. (Delaware County Historical Society.)

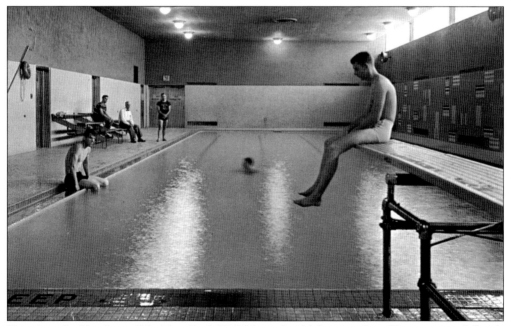

Here is an inside view of the Eyre Park YMCA pool, which was enjoyed by many until floods heavily damaged the site in 1972. (Delaware County Historical Society.)

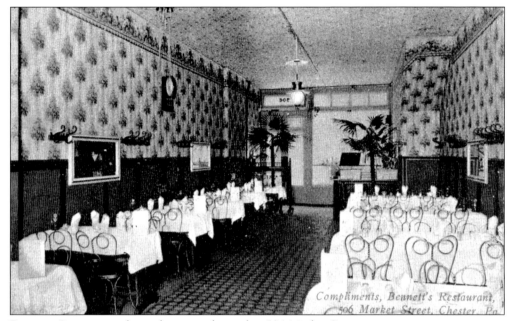

Bennetts Restaurant, shown here, was located at 506 Market Street.

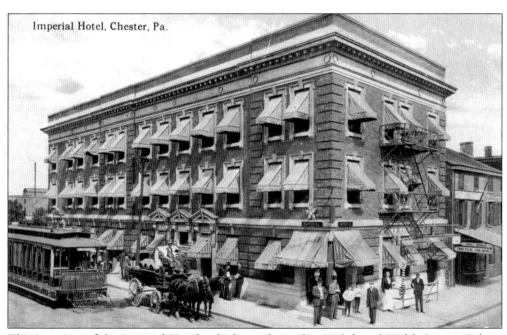

This is a view of the Imperial Hotel, which was located at Eighth and Welsh Streets. It later became the Midtown Inn.

Eight

NEIGHBORHOODS

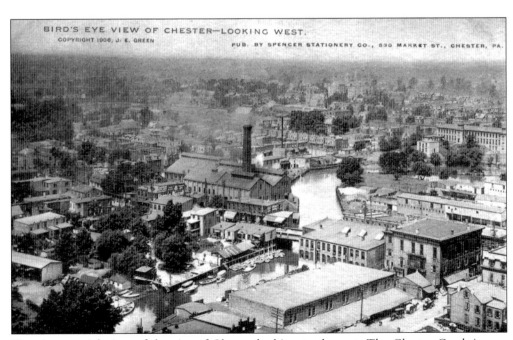

Here is an aerial view of the city of Chester looking to the east. The Chester Creek is seen running through the industrial district toward the Delaware River.

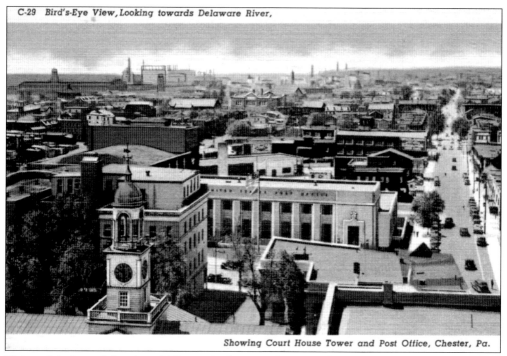

C-29 Bird's-Eye View, Looking towards Delaware River,

Showing Court House Tower and Post Office, Chester, Pa.

This aerial view of the city of Chester looks toward West Fifth Street, and it depicts the post office and the cupola of the new city hall.

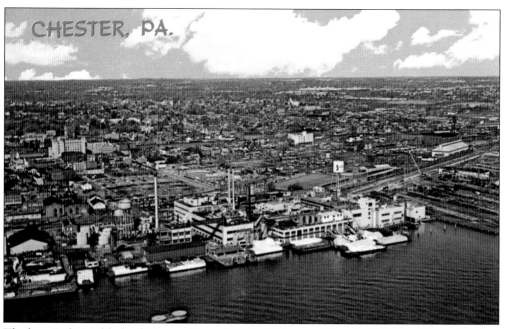

CHESTER, PA.

The busy industrial hub of Chester located on the Delaware River is visible in this aerial view taken in 1964.

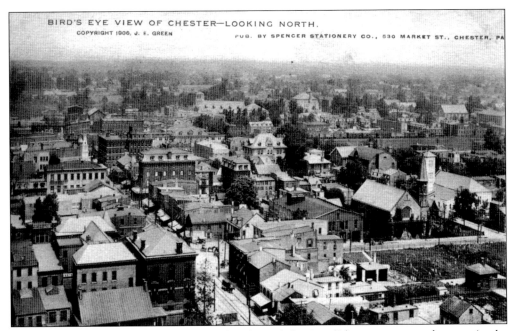

This aerial view shows old St. Paul's Church, and the Swedish cemetery can be seen in the lower right corner.

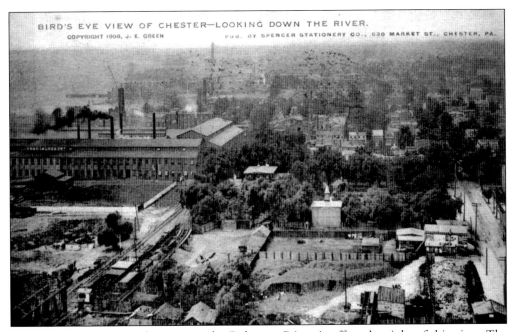

Although not visible in the picture, the Delaware River is off to the right of this view. The tracks of the Baltimore and Ohio Railroad are coming in from the lower left.

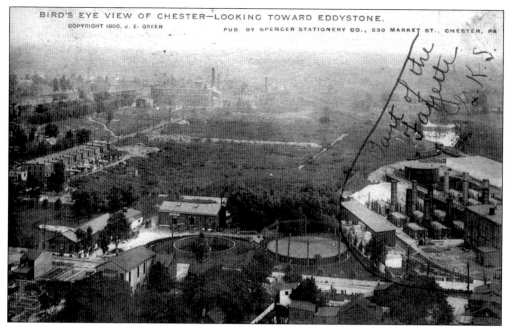

The year 1908 was an eventful, if not a proud, year for Chester. Along with the trolley strike, the city was suffering from a string of burglaries. These ended when three police officers raided a small shack made of railroad ties that was built along the Reading Railroad tracks near the Fayette Works. Within the shack were a number of stolen items, and several young men were taken into custody.

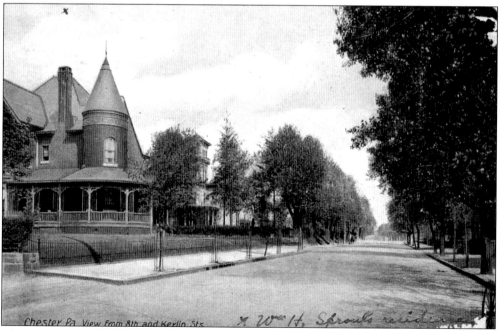

This is a view taken from Eighth and Kerlin Streets showing the Roach mansion. The mansion was the home of John B. Roach, the owner of Roach's Shipyard.

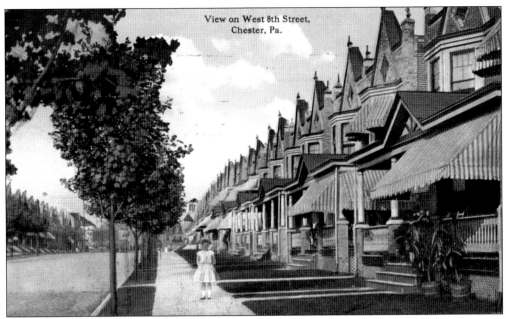

Here is a picturesque view of Holy City, located on West Eighth Street. Many of the homeowners were local merchants.

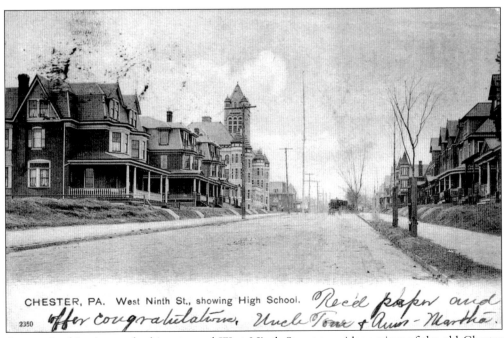

As seen in this picture, looking toward West Ninth Street provides a view of the old Chester High School.

Here is a tree-lined view of East Broad Street, which is often referred to as "doctor's row."

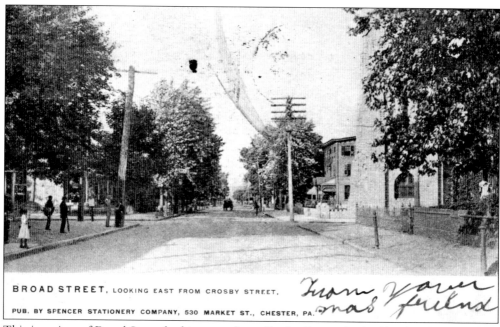

This is a view of Broad Street looking east from Crosby Street. St. Paul's Church is the large building behind the tree on the right.

CHESTER, PA. East Broad Street.

3108 • Spencer Stationery Co., Chester, Pa. (Germany)

Here is a view of Broad Street in the late 19th or early 20th century. Note that all the vehicles on "doctor's row" are horse and buggies.

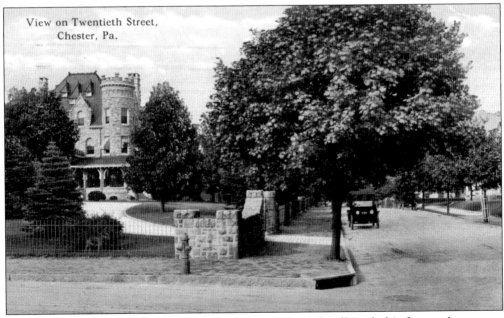

View on Twentieth Street, Chester, Pa.

This is a full view of the Wetherill mansion. Robert Wetherill made his fortune by, among other things, manufacturing Corliss engines for steamships.

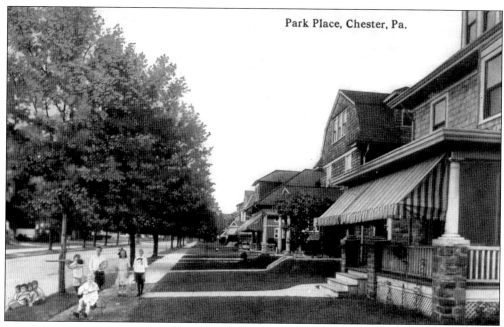

Park Place was a development built around Chester Park about 1903 by Frederick A. and William E. Howard. The boundaries included Gray Street, Edgmont Avenue, Twenty-third Street, and Upland borough.

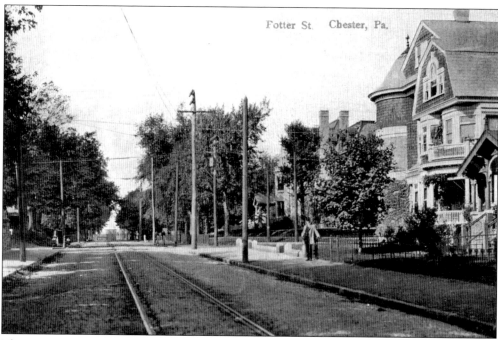

This is a view of Potter Street and the trolley tracks. In its heyday, Chester had over 95 miles of trolley tracks running throughout the city. (Delaware County Historical Society.)

Nine

ODD AND WHIMSICAL

This 1907 letter carrier postcard sends greetings from Chester.

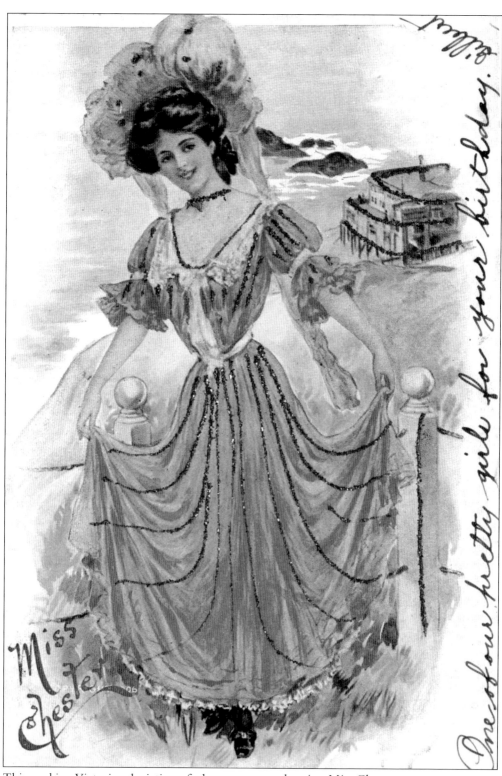

Miss Chester

One of our pretty girls for your birthday. Will.

This card is a Victorian depiction of a beauty queen, showing Miss Chester.

They surprise you in

Chester, Pa.

This postcard indicates that one is in for a great deal of surprises when in Chester.

Chester was a popular destination for visitors in the early 20th century. This postcard suggests that one could party hard but might have an aching head the next day.

This card states, "It's Lonesome Without You in Chester, Pa. Wish You Were Here."

THE TWENTY-SECOND ANNUAL DONATION DAY OF CHESTER HOSPITAL

Will be on Tuesday, October 13, 1914

Our Needs—Money for Maintenance
Household Linen
Old Muslin
Groceries
Fruit
Vegetables

Please make checks payable to "The Chester Hospital."
The Managers will be glad to show visitors over the building.

For many hospitals across the nation, operating funds can be hard to come by, and Chester Hospital was no exception to this. It declared its very own holiday and called it "donation day." It was an open house event where visitors were encouraged to donate money to aid in the care of their sick or injured fellow citizens.

Many novelty postcards depended on visual puns for their humor. This one made a good Valentine's Day icebreaker for the shy guys.

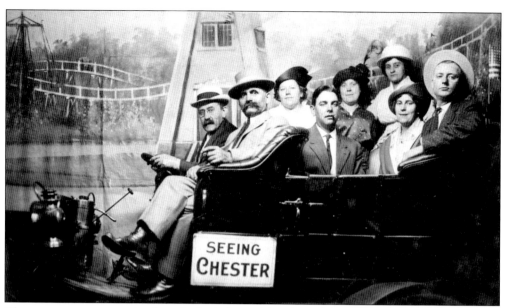

Chester was a great tourist draw in its industrial heyday, and it is becoming one again with the opening of Harrah's racetrack and casino and the projected construction of Chester's first professional soccer stadium. Shown is the early-20th-century version of the Wild West or gangster fun portraits of today.

Delaware County Trust Company

Fifth and Market Streets

Title Department CHESTER, PA.

This postcard is from the Delaware County Trust Company, showing the front view of a recorded deed. Applicants had to sign and return the card as a final step in recording their deeds.

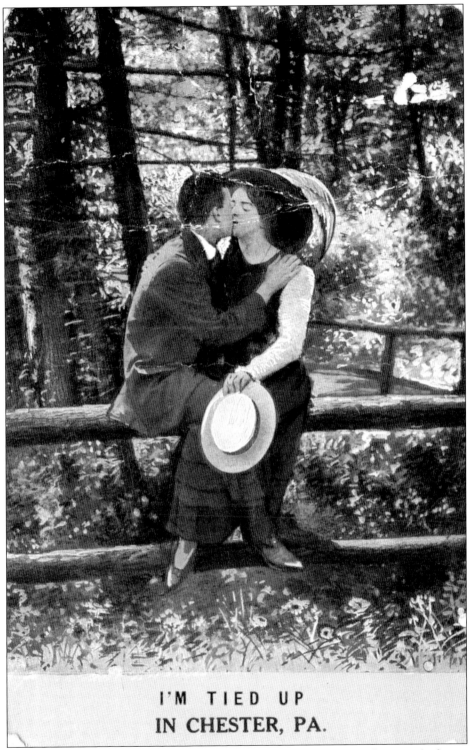

I'M TIED UP
IN CHESTER, PA.

This postcard, which reads, "I'm tied up in Chester, Pa.," is a whimsical postcard of a couple kissing on a fence.

ACROSS AMERICA, PEOPLE ARE DISCOVERING SOMETHING WONDERFUL. *THEIR HERITAGE.*

Arcadia Publishing is the leading local history publisher in the United States. With more than 3,000 titles in print and hundreds of new titles released every year, Arcadia has extensive specialized experience chronicling the history of communities and celebrating America's hidden stories, bringing to life the people, places, and events from the past. To discover the history of other communities across the nation, please visit:

www.arcadiapublishing.com

Customized search tools allow you to find regional history books about the town where you grew up, the cities where your friends and family live, the town where your parents met, or even that retirement spot you've been dreaming about.